25 Helvetica UltraLight	26 Helvetica UltraLightItalic	35 Helvetica Thin	36 Helvetica ThinItalic	45 Helvetica Light	46 Helvetica LightItalic	55 Helvetica Roman	56 Helvetica Italic	65 Helvetica Medium	66 Helvetica MediumItalic	75 Helvetica Bold	76 Helvetica BoldItalic
85 Helvetica Heavy	86 Helvetica HeavyItalic	95 Helvetica Black	96 Helvetica BlackItalic	B Franklin Gothic Demi	Bauhaus Bold	Bauhaus Demi	Bauhaus Heavy	Bauhaus Light	Univers 55 Oblique	Univers 57 Condensed	Univers 57 CondensedOblique
Univers 65 Bold	BO Univers 65 BoldOblique	Univers 67 CondensedBold	Univers 67 CondensedBoldObl	Blk Univers 75	BlkO Univers 75 BlackOblique	Cochin	25 Helvetica UltraLight	XB Memphis ExtraBold	AdLib BT	Apollo MT	Apollo MT Italic
Zapf Chancery	Trebuchet MS	Helvetica	B Aachen Bold	BellBottom	Swing	Rockwell ExtraBold	Rockwell Italic	Oxford	Hoefler Text	AGaramond	AGaramond Italic
Plantin	Plantin Bold	Gadget	Galliard	Georgia	Geneva	Albertus MT	Albertus MT It	Albertus MT Lt	Anastasia	Apollo MT	Apollo MT Italic
Akzidenz Grotesk BE	Akzidenz Grotesk BE Bold	Akzidenz Grotesk BE BoldCn	Akzidenz Grotesk BE BoldEx	Akzidenz Grotesk BE BoldExIt	Akzidenz Grotesk BE BoldIt	Akzidenz Grotesk BE Cn	Akzidenz Grotesk BE Ex	Akzidenz Grotesk BE It	Akzidenz Grotesk BE Light	Akzidenz Grotesk BE LightCn	Akzidenz Grotesk BE LightEx
BellGothic Blk BT	Bembo	Bembo Bold	Bembo BoldItalic	BI Cheltenham BoldItalic	BI Cochin BoldItalic	BI Courier BoldOblique	Akzidenz Grotesk BE Md	Akzidenz Grotesk BE MdCn	Akzidenz Grotesk BE MdCnIt	Akzidenz Grotesk BE MdEx	Akzidenz Grotesk BE MdIt
Franklin Gothic Heavy	Charcoal	Impact	AG Book Stencil	B Goudy Bold	Optima	Optima Bold	Optima BoldItalic	Univers 45 Light	Univers 45 LightOblique	Univers 55	Akzidenz Grotesk BE Super
RotisSansSerif	RotisSansSerif Bold	RotisSansSerif ExtraBold	RotisSansSerif Italic	RotisSemiSans	RotisSemiSans Bold	RotisSemiSans ExtraBold	RotisSemiSans Italic	RotisSemiSans Light	RotisSemiSans LightItalic	RotisSerif	FrenchScript
Zapf Chancery	AGaramond ItalicOsF	EgizianoClassic-BlackTextOL	Bigband	Futura CondExtraBoldObl	Blk VAG Rounded Black	Impact	JournalItalic	JournalText	JournalUltra	L Memphis Light	LB Helvetica Black
VAG Rounded Thin	Trebuchet MS	XB Futura ExtraBold	Eurostile	Eurostile Bold	Eurostile BoldCondensed	Eurostile BoldCondensed	Hoefler Text	25 Helvetica UltraLight	Verdana	Wingdings	Sand
BlurLight	BlurMedium	Grotesque MT	Grotesque MT Bd	Grotesque MT Bd Ex	Grotesque MT Bl	Grotesque MT Cn	Grotesque MT It	Grotesque MT Lt	Grotesque MT Lt Cn	Grotesque MT Lt It	Grotesque MT X Cn
Meta-Bold	Meta-Normal	News Gothic MT	News Gothic MT Bd	News Gothic MT Cn	News Gothic MT Cn Bd	News Gothic MT It	Albertus MT	Albertus MT It	Albertus MT Lt	BC Folio Bold Condensed	BlurBold

A RotoVision Book

Published and distributed by RotoVision SA

Rue du Bugnon 7

CH-1299 Crans-Près-Céligny

Switzerland

RotoVision SA, Sales & Production Office

Sheridan House, 112/116A Western Road

Hove, East Sussex BN3 1DD, UK

T +44 (0)1273 72 72 68

F +44 (0)1273 72 72 69

E-mail: sales@rotovision.com

www.rotovision.com

10 9 8 7 6 5 4 3 2 1

ISBN 2-88046-563-X

Book design by Mono
www.monosite.co.uk

Production and separations in Singapore by
ProVision Pte. Ltd.

T +65 334 7720

F +65 334 7721

>

Branding

From Brief to Finished Solution

Written and Designed by Mono

contents >

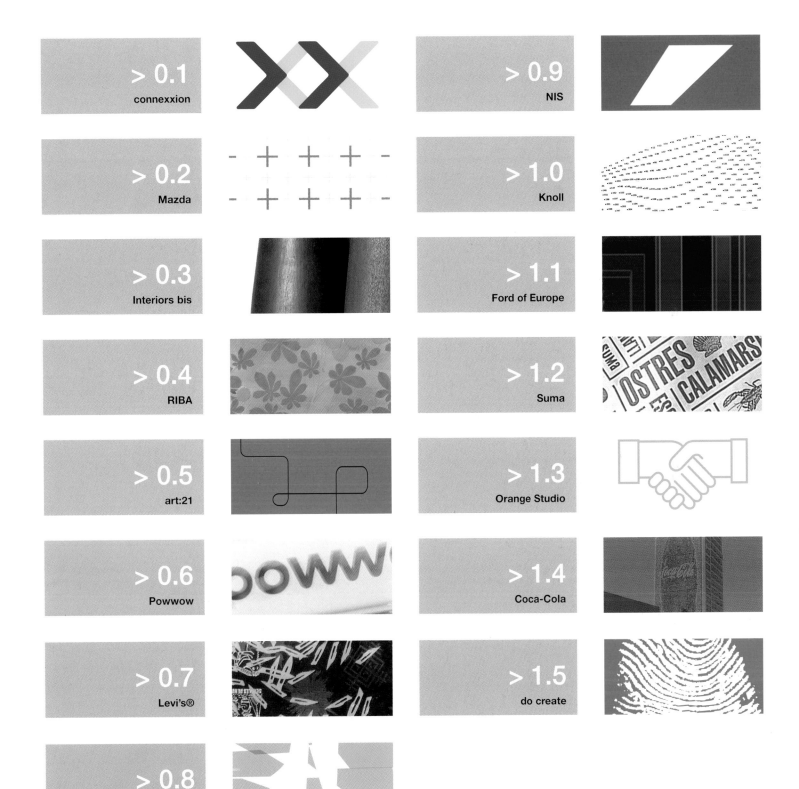

> 0.1
connexxion

> 0.2
Mazda

> 0.3
Interiors bis

> 0.4
RIBA

> 0.5
art:21

> 0.6
Powwow

> 0.7
Levi's®

> 0.8
IBM

> 0.9
NIS

> 1.0
Knoll

> 1.1
Ford of Europe

> 1.2
Suma

> 1.3
Orange Studio

> 1.4
Coca-Cola

> 1.5
do create

intro

\>

Is a brand a product, a service or a company? Is it a logo, a marketing strategy or an attitude?

The definition of a brand is perhaps elusive because of semantic generality, where a brand can be 'a particular product or a characteristic that identifies a particular producer' (*Collins English Dictionary*). It is accepted that a brand can be both the producer and the product that is produced. We can assume that 'product' is not solely a physical, tangible entity, but can be a service, such as telecommunications, vehicle recovery or an internet service provider. In Per Mollerup's *Marks of Excellence*, the distinction is made between 'freestanding product brands and more generalised corporate brands', assuming that the first definition is more relevant to the general perception of a brand. Naomi Klein's *No Logo* provides a very different interpretation of the brand as 'the core meaning of the modern corporation'. This more accurately reflects the nature of brands in today's climate of globalisation, where a corporation must sell a product to potential consumers worldwide across the whole spectrum of languages and cultures. But the various interpretations of brand in media and design necessitate a broad definition of what constitutes a brand. The definition must respond to the general interpretation – as much because brand is an elusive concept, as to the fact that it is constantly developing and redefining its boundaries.

The power of brands has effected the absorption of successful brand names into everyday parlance: Hoover has become a noun for any brand of vacuum cleaner; Tannoy has become a general term for public address systems; Walkman is synonymous with portable sound systems, regardless of whether the manufacturer is Sony, the proprietors of the brand name. But brands can be more than manufactured products. Madonna has been consistently packaged, branded and rebranded throughout her career. This has sustained a momentum that has cemented her position as the most successful female singer of all time. English football club Manchester United discreetly dropped the F.C. from their club badge when floated on the stock market. This signalled the establishment of Manchester United

the brand, and intensive marketing and merchandising of the brand has enabled Manchester United to become the richest football club in the world. Upon taking office in 1997, British Prime Minister Tony Blair approached Great Britain as a marketable brand, generating the strapline of 'Cool Britannia' to promote the country's image around the world.

'Branding' can be seen as the devolution of a set of core values to some or all of a person, company or thing's products, assets and attributes, in the form of an identity. The identity can include the visual manifestation of these values, the embodiment of the desired personality, and can take many forms. Identity encompasses all the taxonomic aspects of a trademark – lettermark or logotype, picturemark, typefaces and colours. But it also involves the ethos, ambience and consumer perception surrounding the product. The Nike global website states that, 'Our identity is more than a swoosh splashed on a product. Our identity is the relationship we have with the world we touch'. This is in accordance with Klein's 'core meaning of the modern corporation' and encapsulates the almost spiritual resonance of many modern brands.

Throughout this book we will study a cross-section of contemporary brands, from the global 'superbrands' of Coca-Cola, IBM and Ford, to less well known, but no less compelling brands with more localised relevance. We will focus predominantly on the development of brand identity from brief to execution, and the means of communicating this identity through various media.

'In its curious, direct way, branding is extraordinarily potent. It reaches beyond immediate commercial objectives and touches the soul – and don't its practitioners know it!' – *Corporate Identity – Making Business Strategy Visible through Design* by Wally Olins.

0.25 pt

0.5 pt

0.75 pt

1.5 pt

2.5 pt

5 pt

7.5 pt

10 pt

0.25 pt

0.5 pt

0.75 pt

1.5 pt

2.5 pt

5 pt

7.5 pt

10 pt

0.25 pt

0.5 pt

0.75 pt

1.5 pt

2.5 pt

5 pt

7.5 pt

10 pt

project 0.1 connexxion

A climate of protest and reaction against globalisation and corporate power has arisen in recent years, which has offered an alternative viewpoint on the function and influence of branding. Voices such as those at *Adbusters* magazine, George Monbiot (*Captive State*) and Naomi Klein (*No Logo*), have raised awareness of branding's proclivity to homogenise and depersonalise. But whereas the anti-branding opinion may suggest that the uniformity engendered by branding can strip cultures worldwide of their individuality and diversity, we should not lose sight of the benefits of branding as a tool for unification, coherence and reassurance. The comfort through familiarity which branding affords, inspiring feelings of safety and loyalty in the consumer, cannot only be utilised for sales and profit but can also communicate vital information clearly and efficiently for the benefit of the public. This was the case with Holland's public transport system.

Like many industries in the 1990s the Dutch transport sector was deregulated, introducing competition from the private sector. As a result, existing operators were forced to reduce their market share, and the four regional public transport operators in central Holland (Midnet, NZH, Oostnet and ZWN, which operated most of the key bus, tram, ferry and taxi services), were brought together under the holding name VSN1 in order to form a new group that would be able to survive in a much more competitive market. The merger needed to be communicated to all external and internal audiences in the form of a comprehensive corporate identity. In 1998 the London- and Amsterdam-based corporate and service branding team at Design Bridge was appointed as branding consultant after winning a competitive pitch.

The client's objectives included raising the prominence of their position in mass market transportation, and the maximisation of passenger, client and employee satisfaction. In order to fulfil these aims and to gain an understanding of the job in hand, Design Bridge assessed the existing transport brands and their competition, the company culture and characteristics of each of the four transport operators, and the public's needs and perceptions of public transport in Holland.

The solution – connexxion – was built around the idea of 'bringing people together', and provided recognisability and expression within a unified and coherent corporate identity. The strength of connexxion lies in its 'modular' visual identity – it consists of several elements which interact coherently as a whole, but which can be disassembled into constituent parts for use in various contexts, without a loss of recognisability and legibility. The xx element is a visual 'hook', an instantly recognisable symbol which evokes connectedness and unity. Its interpretation as either interconnected x's or bi-directional arrows economically expresses both 'bringing people together' and total transportation. The scale of the design programme necessitated the creation of a flexible 'masterbrand' strategy. This helped to facilitate the communication of the identity across a number of specialist service brands and forms of media. This involved supplying brand guidelines to local design agencies whose task it was to apply the identity within their locale. Design Bridge orchestrated the initial implementation in order to establish the brand and maintain standards.

As a branding exercise, Design Bridge's solution encompasses all aspects of traditional corporate identity, and successfully provides the organisation with an individual and high profile identity. Connexxion has become a prominent feature of the Dutch landscape, and is a familiar and trusted brand for those with whom it has come into contact.

'Brands and marketing communication are part of (an) extended aesthetic experience. In a surplus society, in which people are condemned to freedom, brands reduce uncertainty.' – *Funky Business* by Jonas Ridderstråle and Kjell Nordström.

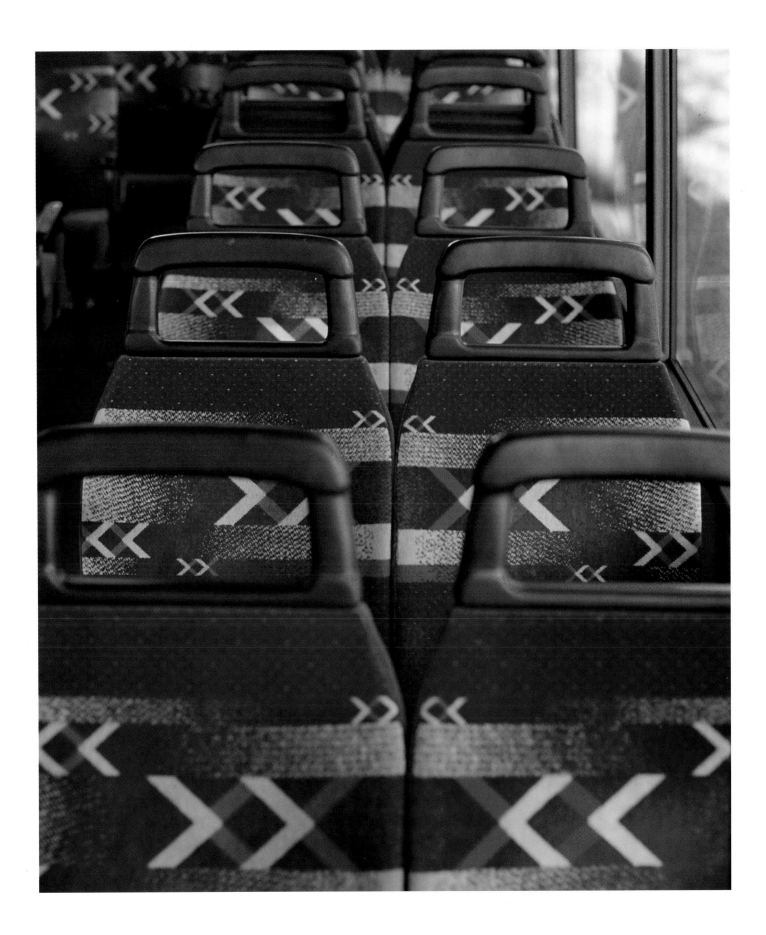

0.1 transport brands (before) ↗

In the initial stages of such a complex branding project, Design Bridge compiled an overview of all regional Dutch transport companies. The findings demonstrate a variety of identities that were all functional, but had no coherent visual approach. Several of these identities are for comparable services, yet confusion within this merged group is caused through the many branding approaches taken by individual companies, with some concentrating on region and others focusing on services.

0.2 audit and initial research ↓ ↙

An extensive brand audit was undertaken (by Nijkamp and Nijboer), documenting all existing brands and their applications. The findings revealed a lack of brand consistency, clearly demonstrated by the array of regional bus liveries. In conjunction with this audit Design Bridge researched European transport identities to identify specific successes, failures and general trends in transport branding. Key competitors were identified in Arriva and Hermes.

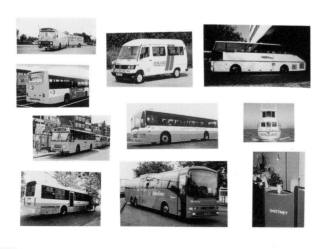

0.3 consumer research ↙

Street interviews were used to formulate a view of users' perceptions of public transport in their respective areas. In response, the public were able not only to name, but often accurately draw, their respective companies' identities. However, while these brands were distinctive 'stand out' marks, very few people had any inkling as to what they 'stood for'. Two major conclusions were drawn from this exercise: that the existing brands were highly generic, and perhaps more importantly, that using public transport was not seen as a positive activity.

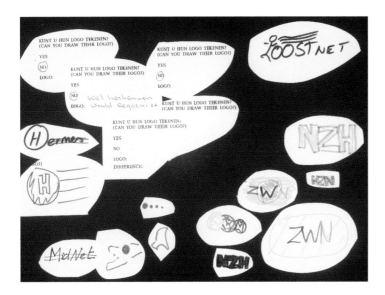

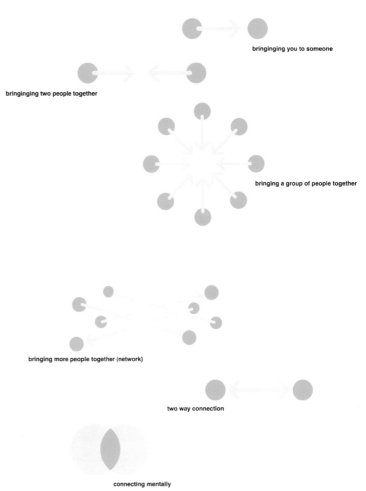

bringinging you to someone

bringinging two people together

bringing a group of people together

bringing more people together (network)

two way connection

connecting mentally

0.4 positioning options ↙

In order to differentiate the new brand from competitors, Design Bridge decided to focus on the primary benefits of public transport. Seven possible positioning themes were developed ranging from the functional (route or price specific), to the more emotional (the experience of travel). Design Bridge recommended that the focus of the brand be that of 'enabler', 'a service that allows you to do what you want to do'.

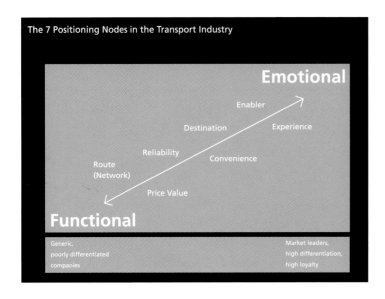

0.5 positioning and naming ↗

Based on the positioning of 'enabler', a statement was developed around which the brand would be built: 'We help you live your life by getting you where you want to be. Whoever you are, wherever you're going, you can trust our friendly, efficient and integrated transport service to take the hassle and frustration out of getting there. We are Bringing People Together.' The schematic above visually explores different interpretations of bringing people together, from a single user visiting another, to multiple users converging on a central location.

Together with Globrands in Holland, Design Bridge developed naming exercises, one of which involved an internal competition to involve staff at the newly merged transport company. 'Connexxion', a name selected for its emotional appeal, distinctiveness and relationship to the brand statement, was one such name submitted by a member of staff. It was felt that the name responded to the identified brand values – friendly, reliable, integrated, enthusiastic, professional, entrepreneurial and efficient – while the double xx spelling made the name more 'ownable'.

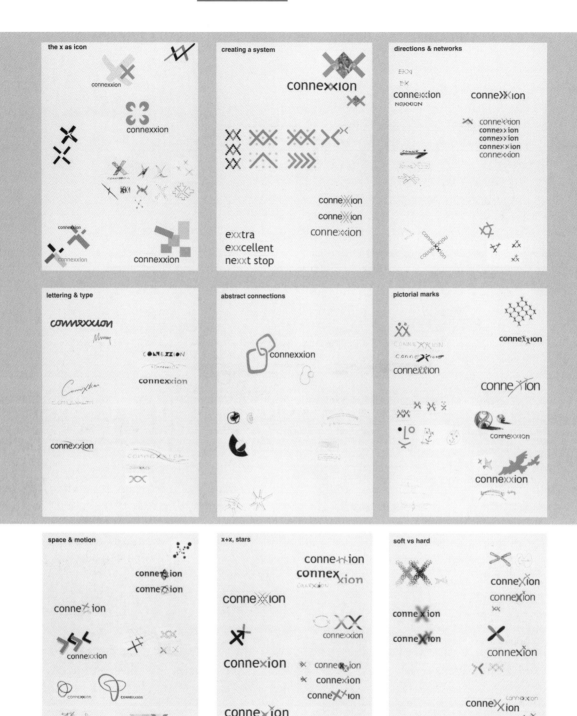

0.6 design concepts ↗

The design team developed a number of design concepts for a connexxion brand mark based on the brand positioning and the brand name. Initial sketches included designs that were not based on the xx elements.

However, when combined with the brand name the xx in the logotype was so overpowering that any additional elements visually clashed. Design Bridge therefore concentrated on the x element as the key feature of the brand mark, as a stand-alone element or part of a logotype. All designs were presented in black and orange on boards, which served as a default colour before any decisions on colour had been made. The boards illustrated layout options for the elements as well as ideas for the visual tone of voice (e.g. hard or soft shapes, dynamic or static shapes).

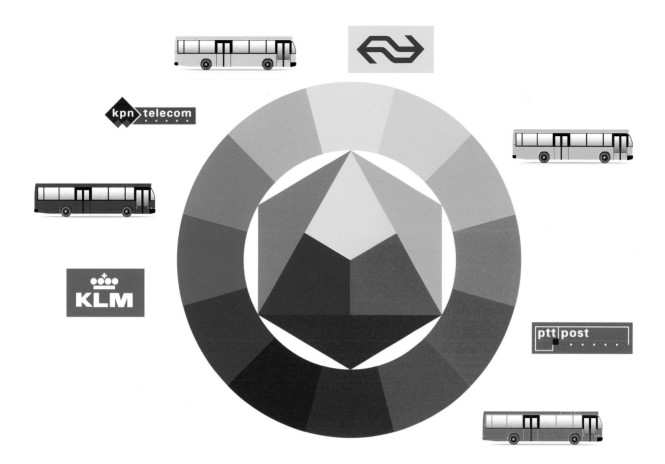

0.7 colour wheel ↗

In public transport identities one of the most distinctive design elements is colour – London buses and New York cabs are perfect examples of this. A public transport identity features prominently on a fleet of vehicles and therefore becomes a characteristic of a city, region or country's visual landscape. Colour also serves the function of differentiation. It is easier to see which company's bus is approaching if it features a distinctive colour.

The colour or colour combination needs not only to be different to other similar public transport brands, but also to well established national brands that would appear on a fleet of vehicles. In Holland for example, the KLM blue would not be used for another prominent brand in the public domain. The colour wheel identifies areas within the colour spectrum which can be owned by an organisation.

0.8 arrow system →

Having decided on using the xx as a key feature in the identity, Design Bridge investigated the options of combining the two elements to express the essence of the brand. The xx as a stand-alone device, and as a component of a logotype, were both considered.

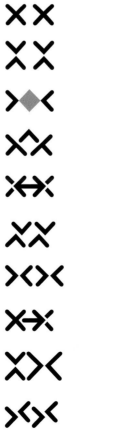

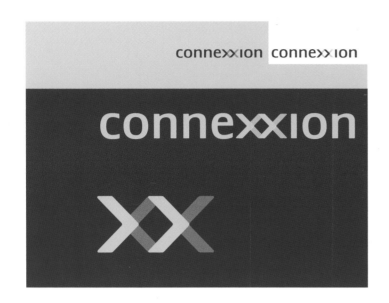

0.9 logotype and brand icon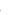

The final logotype incorporates the xx as two sets of arrows moving towards each other and overlapping to create the letter x. The design reflects the idea of 'bringing people together'. It was important to safeguard legibility while creating a distinctive design feature within the logotype. The xx device can also be used separately from the logotype to act as a simple and strong icon employable in a similar way to the London Underground symbol. The icon acts as a beacon that can be seen from long distances.

The logotype design is based on the Lesmore font but redrawn to suit the concept. It is rendered in lowercase to emphasise the design feature of the xx, which would be incompatible with the logo if it had an uppercase C.

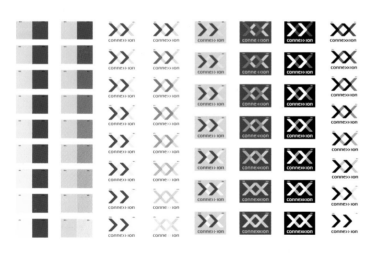

1.0 colour usage

Colour exercises led Design Bridge to choose a dark and a bright green. The colours are distinctive and differentiate the brand. They also have positive environmental connotations and fulfil a number of practical requirements: visibility on livery (safety), sufficient contrast between the two tones to allow the use of coloured type upon a background of another corporate colour, and parity with the screen-safe colour palette used on the worldwide web.

The brandmark was designed to work on white, dark and bright green backgrounds, as well as on a single-colour or black on white version.

 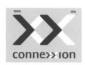 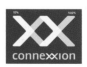

The Sans

ABCDEFGHIJKLMNOPQRSTUVWXYZ
abcdefghijklmnopqrstuvwxyz
1234567890

The Sans Bold

abcdefghijklmnopqrstuvwxyz
1234567890

1.1 choice of brand typeface ↓ ↑

A complex type exercise was conducted to test a range of selected sans serif typefaces for:

• legibility in small sizes (timetables) and from long distances

• typesetting qualities (lining up within timetables)

• legibility and design of numerals (mediaeval or upright)

• visual distinctiveness and personality.

Following these tests, 'The Sans' was chosen as the corporate typeface on all factual information, with its close relative 'The Mix' as a headline typeface for promotional messages. All non-factual body copy (e.g. editorial) was set in ITC Century, a serif typeface that sits well with 'The Sans' family.

'The Sans' combines extreme clarity with a distinctive, friendly personality. It features a comprehensive font family and has become a modern classic. It also works well in both printed and digital form. The fact that its designer, Lucas de Groot, is Dutch was positively received within the organisation.

1234567890 .–-, *f* [({})] !&?/§
abcdefghijklmnopqrestuvwxyz
ABCDEFGHIJKLMNOPQRSTUVW

bold (Officina)

1234567890 .–-, *f* [({})] !&?/§
abcdefghijklmnopqrestuvwxyz
ABCDEFGHIJKLMNOPQRSTUVW

book (Officina)

1234567890 .–-, *f* [({})] !&?/§
abcdefghijklmnopqrestuvwxyz
ABCDEFGHIJKLMNOPQRSTUVW

bold (Letter Gothic)

1234567890 .–-, *f*[({})] !&?/§
abcdefghijklmnopqrestuvwxyz
ABCDEFGHIJKLMNOPQRSTUVW

book (Letter Gothic)

Officina Tables

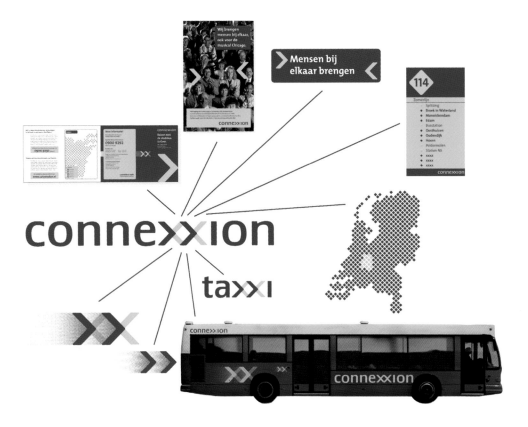

1.2 contextualisation ↑

A brandmark alone does not make an identity. Therefore Design Bridge introduced a stage of work into the design process which they called 'contextualisation'. The purpose of this exercise was to apply a brandmark to a diverse range of relevant applications in order to assess the strength and flexibility of the design. The contextualisation stage allowed the design team to explore the creative potential of an identity by simulating a branded world. The goal for the connexxion brand was to explore the versatility of the xx devices and to develop supportive design elements if necessary.

The chart above demonstrates the creative application of the xx elements: for layout in print; as speech marks for tactical messages and straplines; for information design purposes; within the taxi brand; and as dynamic devices on livery.

1.3 brand experience ↓

A successful brand will extend well beyond its visual manifestation into the culture of a business (internal and external), and become the guiding principle for any form of customer interaction or service provision.

Design Bridge illustrated below the three key areas that will shape an audience's perception of a transport service: communication, system and process, and image and environment. For example, if the system is not in place to consistently deliver a good service, then the best identity in the world will not change negative perceptions of the brand.

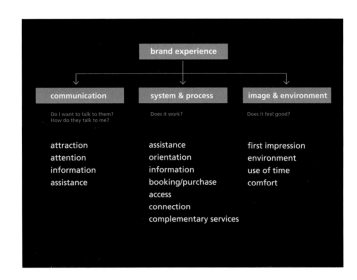

applying a brand language

function → tone of voice

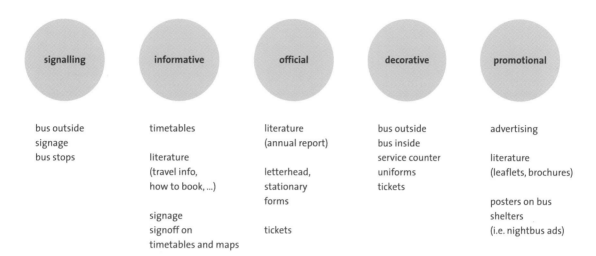

signalling	informative	official	decorative	promotional
bus outside signage	timetables	literature (annual report)	bus outside bus inside	advertising
bus stops	literature (travel info, how to book, ...)	letterhead, stationary forms	service counter uniforms tickets	literature (leaflets, brochures)
	signage signoff on timetables and maps	tickets		posters on bus shelters (i.e. nightbus ads)

1.4 building a brand language ↘

All graphical and typographical elements of a brand identity need to support the positioning of a brand and fit with each other. If this is achieved the identity will be distinctive, relevant and flexible.

In the first stage the primary identity elements are designed (name, logo/logotype, colours). Then the secondary identity elements are developed (image style, type style, layout style, tone of voice, colour palette, brand hierarchy systems). These secondary elements are usually the ones that, when put together and applied creatively, provide the highest degree of differentiation.

While the logo provides a visual key to the brand world, the full expression of the identity only comes to life through the use of the secondary elements. A logo alone cannot do all the work. Once the brand elements are in place, they can be flexibly applied throughout various media to achieve the right expression and tone of voice for the brand.

1.5 applying a brand language ↗

The different elements within the brand language fulfil different roles within the identity. For example, while type style provides a brand with consistency, image style is very much a carrier of emotional messages. The combination of these elements determines the tone of voice of a piece of design. Is it functional, emotional or decorative? What is the primary purpose of an application within the whole communication of the brand?

The diagram above demonstrates the different areas to be considered within a public transport brand and the tone of voice that needs to be applied to key carriers of the brand message. The connexxion brand elements have been applied following these principles. Using tone of voice correctly will result in a brand experience that is credible and consistent. The goal is to build trust in the service and capabilities of an organisation.

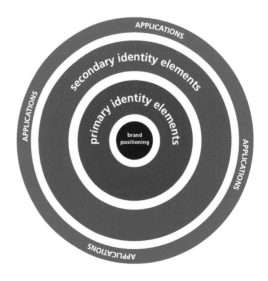

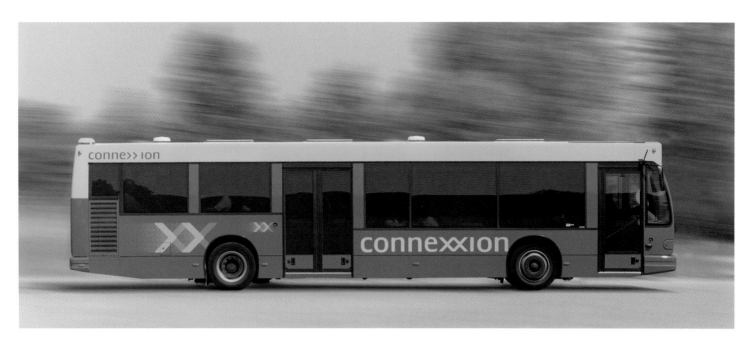

1.6 livery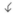

The design of the livery is the most prominent manifestation of the brand. Initial branding activities focused on the bus fleet, both exterior and interior. Key brand elements are employed, particularly externally, to signal the brand. When applying the connexxion brandmark to the side of vehicles, the design of the xx is always adjusted to highlight the set of arrows which point towards the front of the vehicle.

Colour also needs to fulfil safety requirements – bright green is used across buses, on the front of trains and more prominently on ferry boats to achieve visibility. It is also used internally on handrails and bars. Brand elements are used internally on seat fabrics where the need for branding combines with decorative and aesthetic requirements.

1.7 information design systems

Maps, timetables and route-planners utilise the strong typographical style and the bold use of colours of the identity. A visually striking but immediately accessible information system is developed as an integral part of the identity.

To maintain an association with the masterbrand, all iconography that appears in the signage system is taken from the core elements of the logotype. The diamond shape derived from the centre of the xx symbol generates a map of Holland, that through its modular construction can be used to highlight specific areas and routes.

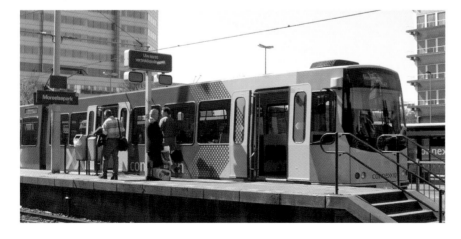

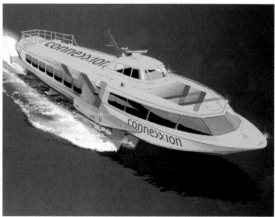

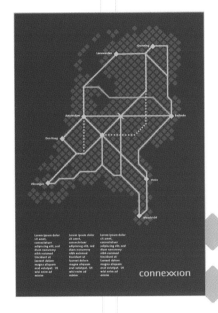

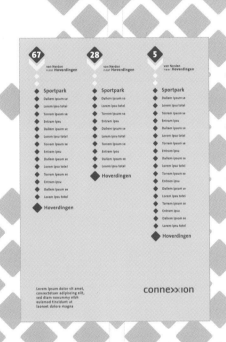

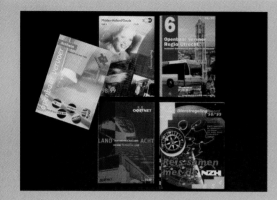

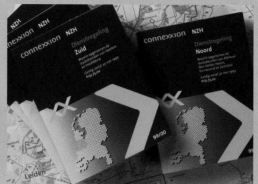

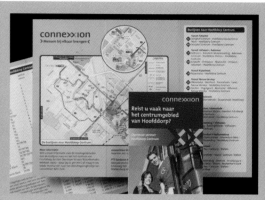

1.8 timetables and literature ↑ ↗ ↓

Prior to the rebranding, all regional operators applied their specific branding and layout style to all literature with varying results. The re-branding exercise gave Design Bridge the opportunity to use one strongly branded look, featuring the connexxion map, across the different regions. While timetables have a strong graphical appearance, promotional or public information literature incorporates photography of people to appear friendlier and more accessible.

All connexxion images show ordinary people in everyday situations. There is never a solitary person in an image, and this underpins the concept of 'bringing people together'. Connexxion images appear either in full colour or as a monotone in dark green. Typography and layout of travel information is simple and clean. All elements used are based on the brand palette established in the brand-language design stage.

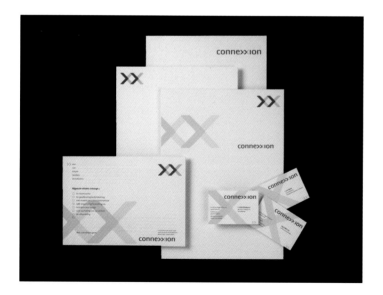

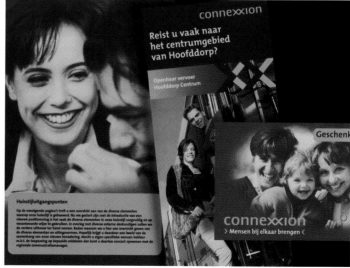

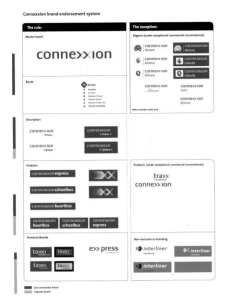

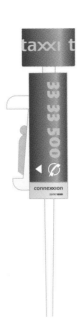

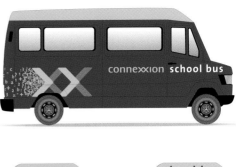

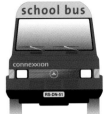

1.9 brand architecture

Having inherited a myriad of brands and sub-brands, it was crucial for the new brand to establish a clear hierarchical structure that would be understood by the public. The decision to establish a strong masterbrand was driven by the intention to bring the four different transport operators together under one banner. The existing brands had too little competitive strength and recognition to be considered as viable alternatives and were discontinued. All sub-brands therefore needed to relate to the connexxion masterbrand. The more valuable a service is, the more prominently it features in combination with the connexxion brandmark. For example, bus route numbers are tied to the masterbrand, but are signalled through use of the diamond device. Express and schoolbus services are of great value to the public and communities and therefore, if displayed prominently, will positively affect the perception of the connexxion brand. The service descriptor is therefore on the same level as the connexxion brandmark. The sub-brand even features a customised arrow device in line with the nature of the service (the alphabet and numerals for the schoolbus).

2.0 brand maintenance

In order to facilitate the correct application of the identity across a widespread geographical area as well as across different media, Design Bridge developed interactive brand guidelines on the connexxion intranet. They achieve several things: they allow the spread of information quickly and accurately in an updateable format; they generate internal buy-in (belief in the brand); they motivate staff to act in line with the brand positioning; and they provide background information on identity issues. Individuals can access all key brand elements from their desktop, a system that allows a central branding team to monitor the use of the brand by logging the user details. Design Bridge also issued conventionally printed interim guidelines for the launch of the brand. These helped to orchestrate the branding efforts undertaken by local design studios and manufacturers of branded materials such as signage and buses.

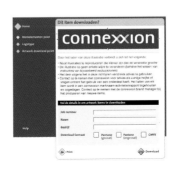

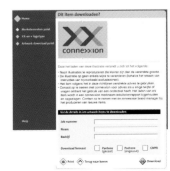

project 0.2 mazda

A co-ordinated and comprehensive identity is essential for brands with a global reach, given that the identity is the face of the brand. Equally important is a brand language that communicates a universal message to all those with whom it comes into contact.

In 2001, the London-based brand experience agency Imagination began work with Mazda to develop a consistent look and feel for Mazda exhibition stands at autoshows around the world. Over time, exhibition design and graphics had evolved to meet the contrasting needs of local markets. The objective was to generate consistency, primarily by leveraging the fact that Mazda is a Japanese brand and expressing contemporary Japanese culture in all its diversity.

The graphic brief was to produce a unified, coherent brand identity that would communicate Mazda's stylish, insightful and spirited nature to autoshow audiences globally. The challenge was to develop a graphic language of integrity that could translate it into spatial settings, print and signage specific to an autoshow environment.

Imagination was the first to acknowledge that, as a European agency, it had to assimilate Japanese culture and seek to avoid stereotypes. An intensive research trip to Tokyo and Kyoto provided some first-hand grounding in the country and its singular character. It also helped establish the parameters of the brief.

The graphic identity had to display the spontaneity and vitality associated with contemporary Japan, but in terms of functionality, it had to be controlled enough to deliver information. Finally, the identity had to evoke the spirit of Zoom-Zoom, the Mazda brand positioning. The sense of movement implicit in the phrase was intrinsic to the design.

After primary research, the first phase of the project was to reduce it to the essentials, paring away the superfluous versions of the existing identity to restate the fundamentals of Mazda. What emerged was founded on paradox: a simple matrix, inspired by the modularity of Japanese architecture, set against an abstract interpretation of Kanji Japanese letterforms. The structured grid came to represent coolness, control and an ordered, almost formal, hierarchy; the digitised characters evoked the vibrancy and energy of today's Japan.

The inherent flexibility of this approach opened up the possibility of generating multiple permutations of shapes and patterns within a unified style to add textural variation and bring the dynamism of Zoom-Zoom to life. The dominant graphic colour was the original Mazda blue, established several decades ago when the Japanese dimension of Mazda was promoted to a far greater degree. This worked alongside the predominantly white architecture of the exhibition stand.

The following pages illustrate the development of the identity and its use at the 2001 international autoshows, showing how it reflects the Japanese principles of balance, harmony and proportion to reaffirm the essence of Mazda for a global audience.

0.1 influences

The identity developed by Imagination drew on traditional elements and reinterpreted them in a contemporary idiom to emphasise the Japanese nature of Mazda and its progressive quality.

This route was, in part, dictated by the desire to return to the original Japanese aesthetic with which Mazda had been associated in the 1970s.

The modular structure characteristic of Japanese architecture generated the concept of a matrix that served as a structured grid, capable of almost infinite depth and variation.

Further visual stimulus was provided by the Kanji letterforms of Japanese calligraphy, reworked in a digital context appropriate to the modern age.

The carefully considered execution of these two constituents exhibited a purity and balance redolent of Japanese culture.

Meeting Room

1

Communications
Room

0.2 process ↑ ↗

The vernacular of the digital letterforms extended to working as information icons. Yellow was selected to serve as a highlight for signage, which distanced it from the Mazda blue and placed it next to white walls, to reinforce the desired impression of sophistication.

Comparative studies of environmental graphics explored the balance between elements, progressing from pure and simple blocks of colour on the modular grid to more playful and expressive combinations of shapes and forms, evoking the Kanji characters.

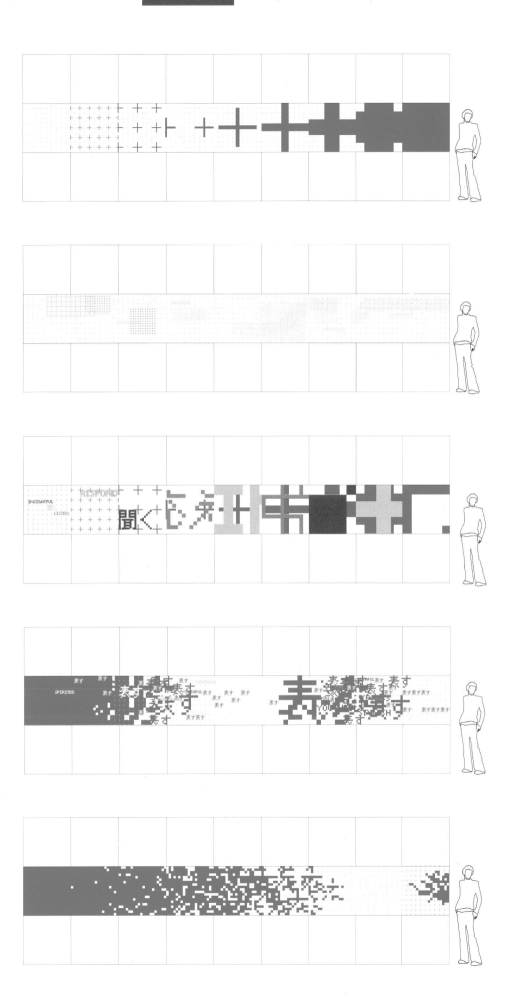

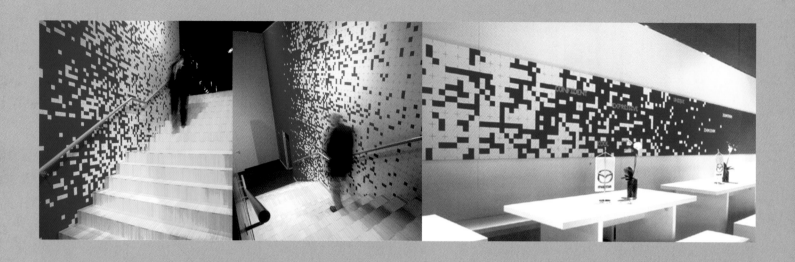

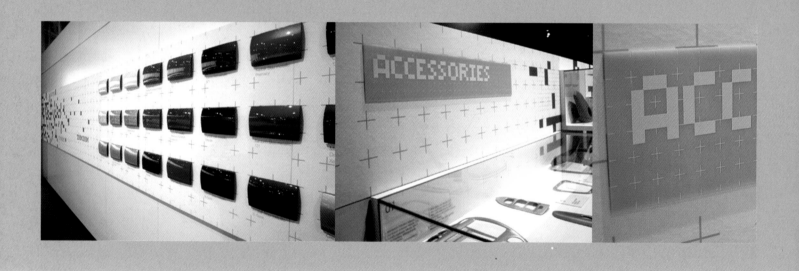

0.3 application

The vehicle for environmental graphics was a textured Japanese paper band – mounted on modular wall panels – which extended around the interior perimeter of the exhibition stand to represent a continuum of dynamic movement.

This device was a contemporary reinterpretation of traditional Japanese packaging. It wrapped the exhibition space and the experience within, thereby reflecting the importance that the Japanese invest in the wrapping of gifts.

Where appropriate, for example in a display of colour panels, the modular grid was utilised as a simple background to anchor the presentation. Another example of this adaptability is in the signage.

The digital letterforms derived from Kanji were rescaled to constitute abstract studies for office environments within the exhibition stand.

0.4 exhibition collateral ↑ ↗

The identity project extended to developing a complete display font, inspired by modular principles. This was utilised for brief large-scale messaging within the exhibition environment.

Japanese expertise in paper engineering provided the starting point for several exercises in book design, featuring high-quality stock, folds and die-cutting to make the medium as visible as the message.

ABCDEFGHIKJ
LMNOPQRSTU
VWXYZ
1234567890

project 0.3 interiors bis

A powerful and recognisable brand presence is essential for survival and commercial success within a marketplace, regardless of the size and market share of the company. For Interiors bis, a specialist interiors and furniture outlet, the need for a distinctive profile was particularly important.

Based in Sloane Avenue in Chelsea, an exclusive area of London replete with furniture and interiors retailers, the company is an individual concern with no national or international presence. In order to signal its ability to compete with larger businesses within the area, such as Peter Jones (of the John Lewis Partnership), Habitat and various independent retailers, Interiors bis needed to establish a brand presence that would stand shoulder to shoulder with its most prominent competitors.

London-based design agency Browns were commissioned to redesign an Interiors bis brand identity that had become tired and neglected. Initial stages of the design process saw Browns undertake thorough research into the client's market sector. Photographs were taken of furniture retailers both in London and New York in order to gain a broad understanding of existing and developing visual trends. This international outlook could give the client a fresh, contemporary edge to provide an advantage over the existing, established brand identities of competitors.

After extensive consultation with the client, both parties concluded that a bold and simple logo, in the form of a monogram of the company's initial letters, would be an appropriate route for the most recognisable aspect of the brand identity. A colour palette consisting of a graduating range of browns, plus a secondary palette of yellow and grey, was developed from which the monogram could draw its 'flavour', depending on its context in a given situation. This colour scheme also devolved to the photography, another key aspect of the brand identity. These images, which accompany the monogram on items such as carrier bags, folders and postcards, consist of close crops of selected Interiors bis products. The images are rendered as duotones, imbuing the cool curves and austere angles of the selected pieces with a twilight ambience and contemporary formality.

The new brand language necessarily maintains Interiors bis' identity as a retailer of furniture and interior accessories. But it also substantially reinforces its profile as the home of premium design products. As with NB: Studio's identity for office furniture designers Knoll (see pp. 102–115), the Interiors bis identity makes use of simple shapes, clean lines and a limited palette of bold, single colours. But whereas the Knoll brand projects a friendly accessibility through the use of warm colours and humour, the earnest, formal qualities of the Interiors bis brand firmly establish it as a place for the exclusive, cementing its presence among the elite of the Sloane zone of Chelsea, and setting it apart from other more mainstream retailers.

'The result is a complete transformation of image, the tangible result being a quantified increase in business. There is also a new-found cultural confidence within Interiors bis, in the way they are communicating to their clients and ultimately in how they themselves are perceived.' – Jonathan Ellery, Partner at Browns.

0.1 developmental logo drawings ↗

Initial developments for the identity were designed to gauge the client's reactions to certain visual languages. Contemporary, classical, serif and sans serif fonts were suggested, as was the graphical device of a dog.

The dog, named Muffin, is owned by the company and was often seen roaming around the shop when Browns visited the client. Browns thought this motif might have been useful as an understated mark, but further developments of this possible ident were deemed too sentimental for a company that wished to be seen in the same light as Prada and Gucci.

0.2 final interiors bis monogram ↑ ↓

In its incarnation as a monogram, 'ib' becomes a visual shorthand, a recognisable shape that retains association with, but can function independently of, the full namemark. But whereas the full version features a capital initial 'I' and a lowercase initial 'b', the monogram is entirely in lowercase. This is done to provide a more pleasing proportional balance between the two letterforms, and to introduce the added element of the circle above the 'i'.

0.3 examples of image manipulation

A series of product shots used throughout the Interiors bis identity were saved as greyscales at 300 dpi, allowing them to be quickly and easily altered within such programs as QuarkXpress. A variety of techniques can then be used to alter the image, including contrast manipulation, halftone adjustment and colour control, as demonstrated opposite.

0.4 brand language – fonts ↑ ↗

A cursory glance at the identities of various furniture and interiors brands such as Ikea, Habitat, John Lewis and Heals, reveals common themes that underpin the most recognisable aspect of the identity – the logo. These include a single-colour name upon a single-colour background, clear and concise letterforms that adopt or are based upon existing typefaces, and an absence of a picturemark.

Browns used an existing typeface, Bauer Bodoni, for the Interiors bis logo. This typeface possesses the necessary classical qualities seen in competing retailers, signalling its identity as a producer of furniture and interiors accessories. But it also has a clean-cut form and distinctive character that sets it apart as a mark of a designer of premium products.

Contractions or abbreviations in competitors' namemarks are rare. The use of initial letters to identify Interiors bis reinforces the individuality of the brand, and suggests that the abbreviation is possible due to customers' familiarity with that brand.

Business cards, letterheads and postcard mailers feature the full version of the namemark in Bauer Bodoni. A secondary typeface, Helvetica 45, is used for the body copy of the various literature items. This open and simple sans serif font provides legibility wherever it is used, and acts as a counterbalance to the heavier, more ornamental forms of the serifed Bauer Bodoni typeface.

0.5 brand language – photography ↙

The use of stylised photography, portraying the products as sculptural forms, provides another element through which the brand can be identified. The use of this imagery on items such as postcards, A4 folders and carrier bags ensures high visibility of both product and brand.

The Interiors bis brand language is primarily a combination of three simple elements: colour, photography and logo. These convey the company's values of a high design aesthetic, a modern, contemporary attitude, and a pride in being a purveyor of the exclusive.

project 0.4 riba

RIBA is the acronym and predominant namemark for the Royal Institute of British Architects. RIBA is a professional body that has existed since 1836, and which is dedicated 'to improve architecture – to benefit the people' ('VSVI CIVIVM DECORI VRBIVM'). It has more than 32,000 members, including such eminent architects as Lord Foster and Sir Nicholas Grimshaw. In the course of its life it has experienced many changes in the way it projects itself, and has recently readdressed its identity to take into account contemporary trends in branding.

The renowned crest is the most recognisable visual aspect of RIBA, and therefore the most precious in the eyes of its members. Originally conceived in 1836, it has undergone several redesigns and has continually been the focus of debate within the corridors of RIBA. Prearmed with the knowledge that even the respected designer Eric Gill's version of 1931 was met with outrage, UK design agency Atelier Works undertook the sensitive task of bringing the crest and brand up to date.

The history and influences of the previous crests were researched by Atelier Works in order to inform the direction of the new design. It was noted that the current crest, a woodcut designed by illustrator Joan Hassall in 1961, was crudely drawn and was unable to effectively meet the demands of today's digital media and modern print processes. In response to the crest's shortcomings, and in acknowledgement of the traditions of RIBA, Atelier Works based the new design on Seaton White's crest of 1931, which adorns the balustrade of the Portland Place headquarters in London. In comparison with the ornate splendour of Gill's design, and Hassall's hand-crafted rendering, White's crest is simple, angular and iconic. It allowed Atelier Works to treat the new design in a similar way to a modern logotype. It was produced as vector line art in Illustrator, and structured with bold, clear areas of contrast that allowed its reduction and enlargement with no loss of detail or legibility. It could also be easily reversed out of the single-colour roundel in which it is optionally displayed. The wording 'Royal Institute of British Architects', which orbits the crest in its circular application, is set in uppercase Unica – a typeface which combines the best of Helvetica, Univers and Akzidenz Grotesk.

With the delicate issue of the crest resolved, Atelier Works addressed RIBA's brand language. It was discovered that Herbert Spencer's scheme of 1961 was the first to address the notion of identity in its modern sense. The scheme defined the appearance of all print and literature, and featured consistent use of colour, typography, format and illustration style. But since the application of a unified identity across all RIBA's output, visual styling and fashions had changed, and the identity had fallen into neglect. The RIBA namemark, typeface and colour palette were inconsistent across publications, websites, exhibitions and regional materials due to the lack of definitive brand guidelines. Atelier Works introduced a lively but balanced colour palette, a limited choice of typefaces, and a set of simple formats that championed the new crest and provided unity across all RIBA's output.

'Whenever a new person comes into contact with RIBA they will form an impression of what the organisation is all about. The better these encounters are, the better the impression will be. The more unified these materials are, the more confident the organisation will seem.' – Quentin Newark, Designer at Atelier Works.

Two very early versions, both dating from 1836

A version of the crest redrawn to resemble the Treasury gate at Mycenae, Greece

Seaton White's crest of 1931 on the Portland Place balustrade

Joan Hassall's crest of 1961

Eric Gill's crest of 1931 – note the sinuous, slender lions and the large, detailed mural crown

0.1 spencer's work ↖

Herbert Spencer's design scheme of 1961 was RIBA's first coherent corporate identity. Formats were standardised, a colour palette was chosen, image treatment determined and primary and secondary typefaces defined. The combined effect provided RIBA with a strong identity, the principles of which have been reflected in Atelier Works' new programme.

0.2 variations of the crest ↖ ↗

'The crest used since 1961 is seen as something inevitable, natural, inviolable. Which, of course, it is not. In fact the RIBA has changed the crest very regularly – about once every thirty years – reinterpreting it according to prevailing ideas. The recent revisions are part of a venerable tradition of reinterpretation.' – Quentin Newark, Designer at Atelier Works.

architecture.com

0.3 as it was ↑ ←

The disparity between colour schemes, logotypes, typefaces, sub-brands
and use of the crest are symptoms of a brand that has lost direction. No
two items shown here, spanning literature, CD-ROMs and websites, feature
similar identities. In the case of the website, even the RIBA name has been
sidelined in favour of the URL address, 'architecture.com', devaluing its
prestige and authority.

NSTITUT RIBA

RIBA

0.4 redesigns – RIBA logo ↗

The new version of the RIBA acronym functions separately from the crest. This enables clear and concise communication of the identity without the need to reproduce the full crest each time the name is referenced.

John Rushworth at Pentagram was responsible for the logo, selecting and adapting the letterforms from an alphabet by Eric Gill, a version of his Perpetua typeface. They emulate the structure and style of the letterforms carved into the stone façade of the RIBA headquarters at Portland Place.

0.5 redesigns – RIBA crest ↗

It is the first time that a sans serif letterform like the Helvetica typeface has featured within the full version of the crest. This simplicity of form prevents interference with the finer detailing of the central illustration. The colour of the circle is standardised as the vivid Pantone 032.

The crest features a modern reinterpretation of the classical lion figures flanking a tower topped with a crown. The geometry of the lions and the proportion of the column are distinctive features of a faintly Egyptian 1930s' deco style – although the column itself is mediaeval, originating in the architectural vogue of 1936 that eulogised England's Gothic past.

0.6 typefaces ↗

After experimenting with the fine-tuning of typefaces as shown above, it was decided that all headline text should be set in Unica. This sans serif letterform provided a distinction from the serifed RIBA logo with which it often appeared, and its weight provided legibility across print and web applications.

0.7 layout ↰

The use of the brand language across print items echoes Herbert Spencer's use of bold bands of colour and clear and compact layouts. The visual style for literature, seen here, has set rules for the size and weight of typeface and position of logo, but has the flexibility to incorporate variations in pictorial style and content without straying from brand guidelines.

'The two treatments reflect changes made between two presentations. The items above and far left show a treatment that uses bold bands of colour, like Spencer's scheme of 1961, or like Penguin books of the 1960s. The approach finally chosen, items shown below and direct left, free the elements from any banding, and integrate them with the colour or photographic surface,' comments Quentin Newark.

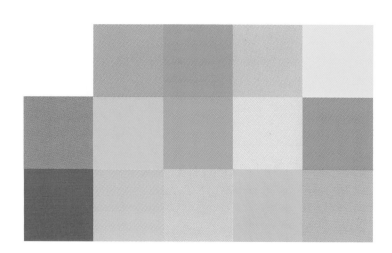

0.8 colour ↗

The colour palette was sourced from drawings and designs held by RIBA (wallpaper sample shown designed by C.F.A. Voysey), a poetic link to architectural history. Colours from this source were also influential and evident in the main crest identity and printed items.

0.9 napkins ↙

Use of self-effacing humour can be seen in the designs for the RIBA cafeteria's napkins, which evoke apocryphal anecdotes of landmark designs beginning life as sketches on napkins. The featured sketches are, respectively: Frank O. Gehry's Guggenheim Museum in Bilbao; Lord Norman Foster's 'blade of light' Millennium Bridge in London; and David Chipperfield's Kaistrasse in Hamburg.

1.0 toilets ↗

The toilet signs are based on figures featured in the architect Le Corbusier's 1948 book *The Modulor*. This proposed a range of modular dimensions enabling designers to deal accurately with standardisation, industrialisation and mass production. The figures are used as graphics within the book to depict 'an harmonic measure to the human scale, universally applicable to architecture and mechanics'. Quentin Newark feels, however, that, 'While many architects will appreciate the playful irony of using Corbusier's figures, the drawing of his woman is grotesque and "unrecognisable as a woman", and needs to be replaced by a more sympathetic image by another architect.'

1.1 application ↘

As the final brand will be applied to many different items, the need for flexibility is crucial; it can be used with photography, illustration, flat colour or computer-generated imagery to equal effect.

Guggenheim, Bilbao, Frank O.Gehry

Millennium Bridge, London, Sir Norman Foster

Kaistrasse, Hamburg, David Chipperfield

project 0.5 art:21

Branding for specific media poses parameters that can be both restrictive and liberating, and that are unique to the respective medium. For instance, branding for a supermarket chain (see Suma pp. 124–133), may involve a broad scope of printed media, from large format to package-specific, which the identity must take into account to facilitate consistency and recognisability of the brand. Branding solely for the web enables the use of moving image and interactivity, but must also consider numerous issues including file size, download times and cross-platform colour restrictions. Similarly, television-specific branding stipulates its own principles, which can both limit and enhance the identity, and to which the designer must respond and turn to the advantage of the brand.

New York-based design agency open: a design studio was commissioned to create the identity for art:21, a series of television programmes featuring American art and artists in the 21st century. The client, Art21 Inc., wanted the series to bring contemporary art to the masses on American broadcasting station PBS. After researching the ways in which art is presented to the public, through museums, galleries, books, magazines and other formats, Open established the brand's core aims as accessibility, diversity, exuberance and objectivity. Open proposed several ways to reinforce these values, presenting the ideas as little books that helped to convey the formats, sequences and storyboarding of the ideas. These books explored themes such as 'Why care about art?' and 'Where does art belong?'. Initial proposals suggested a traditional corporate identity structure including a logo, symbol, colour palette and custom font. The typeface, colour palette and information structure were well received, but the client was not comfortable with the traditional, static approach to the identity and wished to make more of the possibilities afforded by television.

Subsequent proposals explored the possibilities of movement, sequence and space, with an emphasis on written language. The chosen proposal was based upon the theme of a 'stream of consciousness', whereby a single white line creates a path of abstract shapes over a background of flat colours that fade softly from one to the other. The line is a simple and effective vehicle with which to express timelines, along with notions of muse, mood and relationships. Complementary words, such as 'ephemeral', 'dull', 'democratic' and 'ambiguous', which appear as the line progresses, are more direct references evoking the nature of art and the public's opinions of it. An aural collage of artists' voices accompanies the visual sequence.

The identity consists of opening, closing and interstitial sequences, and extends to all graphic elements within the show segments and the art:21 website. It utilises the colour potential of the screen, using the bright and rich colours of the RGB medium that are not available in traditional print-based identities. It also fulfils the initial aims of accessibility, diversity, exuberance and objectivity, the identity appearing warm, friendly and unpretentious, while not competing with the art featured in the series.

The success of this branding exercise cannot be measured in the same way as others, as it is the content of the television series that dictates viewing figures, not the effectiveness of the identity. But the programme has been well received by PBS viewers and has been renewed for a second series.

'Our idea was that we were essentially creating advertising for the idea of (contemporary) art.' – Scott Stowell, Art Director at open: a design studio.

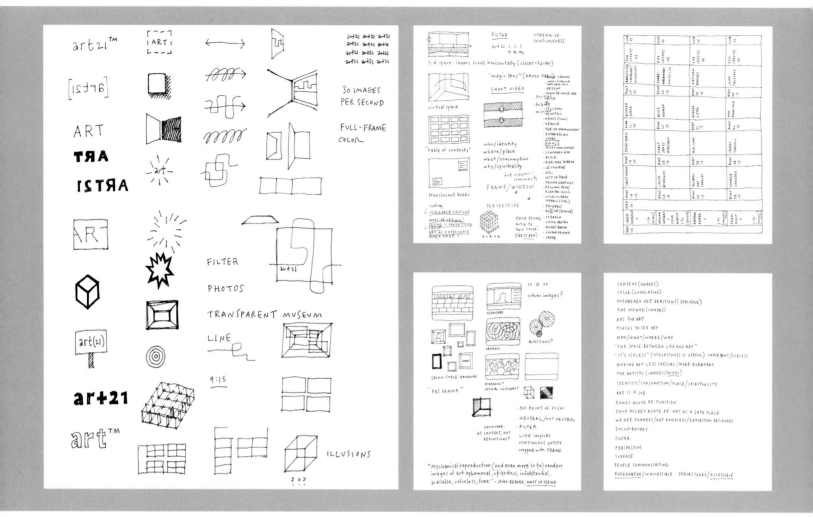

0.1 preliminary sketches ↑

'For us a project like this starts with lots and lots of sketching. These pages from my sketchbooks show some early conceptual development, ideas for the art:21 identity, sources of inspiration for the project, various concepts for the show packaging, a diagram of the segments of the four programmes, the "blink" transition used throughout the final programmes, some (rejected) possibilities for identifying artists on-screen, early navigation sketches for the website, and a glimpse of the chosen design direction for the show packaging.' – Scott Stowell, Art Director at open: a design studio.

0.2 typeface ↗

'We commissioned Tobias Frere-Jones of the Hoefler Type Foundry to design a custom typeface for art:21. The result is called Retina and was originally based on some studies Tobias had created for a font to be used at extremely small point sizes. The same techniques used to insure readability at a small size work well in the low-resolution environments of television and the web. Although Retina was exclusively developed for art:21, a version of it is now in use in its originally planned context: the *Wall Street Journal* uses it for their stock tables,' explains Scott Stowell.

Mel Chin
Michael Ray Charles
Andrea Zittel
Barry McGee & Margaret Kilgallen
Bruce Nauman
Kerry James Marshall
Louise Bourgeois
Sally Mann
Matthew Barney

Retina Broadcast Roman

ABCDEFGHIJKLMNOPQRSTUVWXYZ

abcdefghijklmnopqrstuvwxyz 0123456789

Retina Broadcast Italic

ABCDEFGHIJKLMNOPQRSTUVWXYZ

abcdefghijklmnopqrstuvwxyz 0123456789

0.3 colour ↗

'From the beginning of the project, we knew that colour would play a central role in the art:21 identity. We developed a lively palette of sixteen RGB colours [represented here as their CMYK equivalents] to be used throughout the series. The colours take advantage of the intensity available in the RGB colour space and are designed to reflect the diversity of ideas presented in the broadcasts.'

0.4 client presentations ↗

'Although it's impossible to reproduce all of the many presentations made over the length of the project, above are excerpts from the big ones. For major presentations, we create written documents, presented to the client as wiro-bound books, which explain our thinking and provide examples of the proposed design solutions.'

0.5 route 1 ↗

'The concept behind the first design presentation was the application of a traditional corporate identity system to the more intangible subject of contemporary art. Besides the custom font and colour palette, the presentation included a logo and style frames for the broadcast design. A preliminary structure for on-screen identification and presentation of artworks and other text was also presented.'

0.6 route 2 ↗

'The second presentation focused not on a symbol but on the idea of context. What would act as a framing device for the artists' segments? These ideas would evolve into the show packaging: the opening, closing and interstitial sequences. As the client did not have preconceptions about the packaging, we presented three directions at this point as a way to encourage further dialogue.

'The first concept ("the transparent museum") employed a very concrete metaphor that would be executed with 3D animation. Concept number two ("stream of consciousness") combined a more open-ended visual treatment with a series of words that describe art and the ideas behind it.

'The third direction ("the real world") used documentary photography as a counterpart to the content of the segments. Of these three, the client selected number two as a candidate for further development. At this point, it became clear that written language would play a critical role in the packaging. Much of the work we do is based on language, and in this case the words were a perfect way to be both abstract and meaningful.'

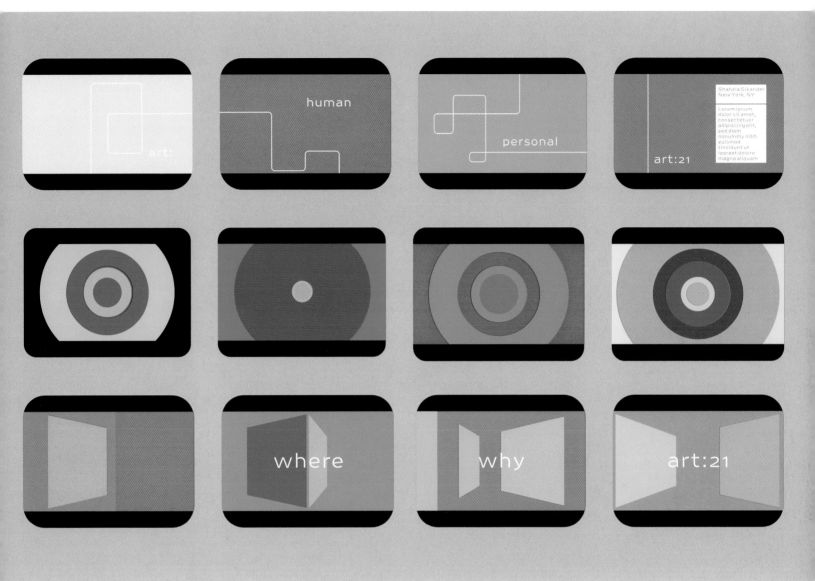

0.7 route 3 ↑

'Based on the result of the previous presentation, we again presented three directions for the show packaging, all of which employed language and operated at a similar level of abstraction. All three directions were presented at this point in a more concrete way – as specific storyboards rather than style frames.

'The first was a refinement of the previously approved concept; the second used radiating circles in overlapping colours and questions that confront the viewer; the third was more structured, incorporating lists of ideas or objects that related to the theme of each programme. At this point, the client reaffirmed its interest in the stream of consciousness idea but was also interested in the other directions. Motion tests of all three were produced. While the first direction was approved, directions two and three may end up being used as the design directions for art:21 seasons two and three, respectively.

'Based on the "art:" in the approved design direction, the art:21 type treatment was developed and has become a de facto logotype for the programme.'

0.8 planning ↑

'After the show packaging direction was approved, the colour palette was refined and adapted for use in print and on the web. We also developed a system to make sure that the sixteen colours were distributed evenly throughout the packaging. And in preparation for the next presentation, investigations were made into the show structure – how on-screen text and artworks would be presented and how all of the various segments of the broadcasts would relate to each other.'

0.9 language →

'Each sequence in the show packaging begins with the word "art:" and continues with a series of adjectives that describe art. The words are meant to be both specific and general, to help viewers relate both to the particular content of the broadcasts and to their own experiences with art. It was important to us to include words that had negative connotations as well as positive ones, to demonstrate the universal qualities of art and to make a connection with the viewer. Had every word been positive, the sequences would have been less challenging, less interesting and less honest.'

art:

everywhere	evocative	celebratory	playful
democratic	old	questionable	intellectual
useless	romantic	lofty	fun
important	obscure	weird	ubiquitous
sexy	pretty	diverse	unbalanced
generous	neat	transparent	stupid
unclear	melancholy	intangible	seductive
purple	intense	transcendent	cool
ephemeral	clean	contentious	traditional
joyful	refreshing	unexplainable	honest
curious	distant	light	trendy
ambiguous	dangerous	invisible	defining
influential	national	happy	hopeful
imaginary	urban	normal	frustrating
flat	sunny	embarrassing	fancy
comfortable	exuberant	lonely	high-tech
festive	thoughtful	hysterical	fantastic
desolate	unknown	risky	elusive
underwater	strange	original	incredible
reflective	essential	political	necessary
timeless	mesmerizing	boring	new
public	alternative	peaceful	fashionable
historical	blue	unusual	easy
beautiful	mysterious	flexible	obsessive
loud	simple	personal	cheap
nostalgic	limitless	serious	modern
large	inspiring	heroic	promising
specific	odd	self-defined	perfect
hot	meditative	emphatic	vague
square	handmade	compassionate	enlightening
spectacular	ecstatic	human	ugly
elsewhere	terrifying	complicated	revealing
familiar	free	substantial	endless
	sincere	inclusive	art:21

PATH 02 ✓

art :21

art:

4 sec.
④

3 sec.
①

4 sec.
②

4 sec.
③

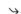

1.0 developments ↗

'This original line drawing demonstrates the development of the animated line used in the show packaging. After a sketching phase, the lines were drawn by hand using a reference grid based on the proportions of the frame. The lines had to be carefully designed for both formal and practical reasons – each line is a very different shape, but all of them had to fit within the maximum element size allowed in After Effects. Next, initial placement of text elements was planned, and key frames and camera moves were indicated. The speed of the line's movement was determined by its length – as the line enters the frame at the beginning of each sequence and leaves at the end, longer lines would move faster than shorter ones.'

1.1 renderings ↝

'To create the final interstitial sequences, the line elements were redrawn in Illustrator and imported into After Effects, where they were combined with the text elements and background colours and animated to match the key frames established in the development stage.

'Although our involvement with art:21 extended to many aspects of the programme and its accompanying website, the opening, closing and interstitial sequences represent the purest expression of the art:21 identity.

'The thin line acts as a thread that connects the various ideas – some general, some specific – about art, while the coloured backgrounds fade almost imperceptibly into each other, creating a seamless experience of light and colour. The result is a virtual environment made up of ideas.'

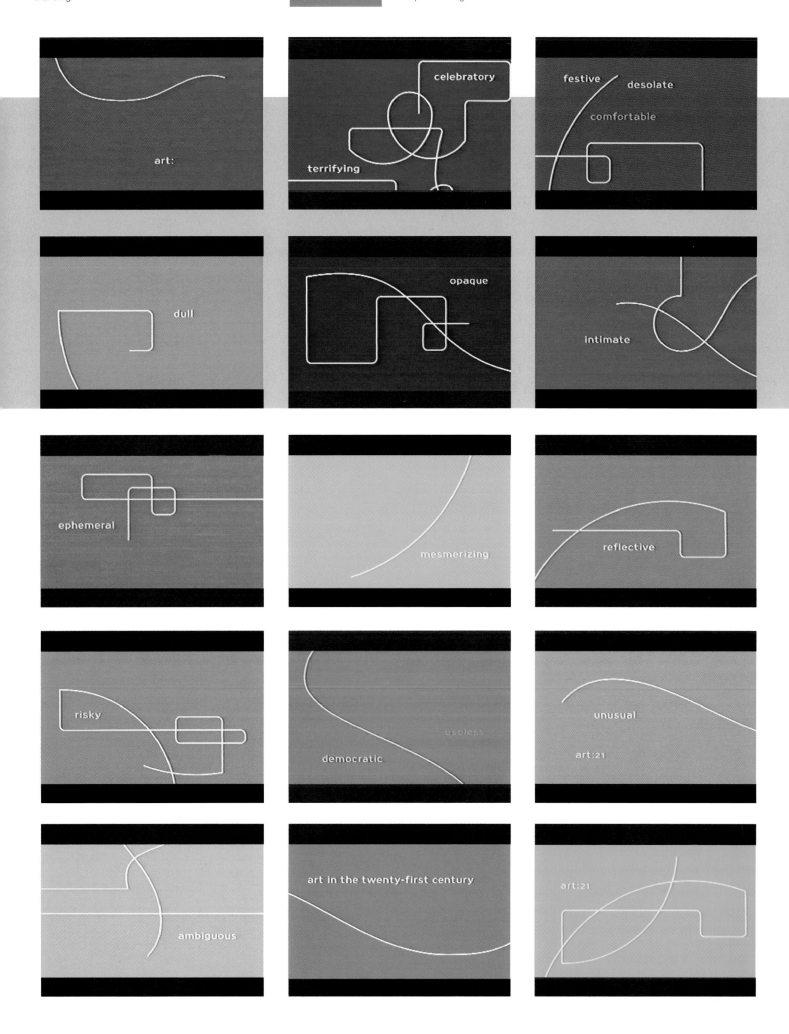

project 0.6 powwow

The marketing of bottled water – a ubiquitous, literally 'on tap' commodity that is taken for granted in a water-rich country like the UK – was the commercial coup of the 1980s. The few existing brands, such as Perrier, were seen as the preserve of the privileged, and were predominantly sold in glass litre-bottles. But the new market supplied water in smaller quantities in more portable plastic bottles, with the intention of competing with the soft-drink market, which sold its beverages in similar volumes. Consumer uptake was remarkably enthusiastic when we consider that prices could be up to 100 per cent more than the soft-drink competition, and exponentially more than tap water. We can attribute this to the success of the brand image of bottled water, which was seen as a healthy designer alternative to soft drinks.

The inevitable progression for spring-water suppliers was the marketing and supply of large quantities of packaged natural water to business premises. This was the challenge faced by Wolff Olins when, in the summer of 1999, they were approached by Watson's Water to brand its new water-cooler business in the UK.

Watson's Water, already established in Asia as a subsidiary of Hong Kong-based conglomerate Hutchison Whampoa, had entered the UK by acquiring a number of bottled water companies. Among them were Crystal Spring and Braebourne – the third and fourth largest companies in the UK water-cooler sector.

The drive to integrate the businesses to gain internal efficiencies led to the natural conclusion that a single brand structure was needed. To assist the integration of the businesses and to reflect the ambition expressed within Watson's Water to do something different, the decision was taken to create a new brand rather than adopt an existing one. Wolff Olins' role was to help its client develop its leadership position and to meet its ambition by defining and realising a compelling brand idea for the company.

They explored what would make the brand special, and what difference it would make to customers, as well as what would differentiate it from its competitors. Their aim was to bring this idea to life within the culture of the company.

Throughout their research and development, Wolff Olins kept in mind that most consumers had little or no opinion or expectations of water. They looked at ways to make the experience of water consumption in an office environment more meaningful, without trying to hype up the product itself. The idea for Powwow came from a combination of observation and imagination. Watson's are an extremely ambitious organisation and were looking to be different. More practically, the water itself is put into bottles, shipped to clients, drunk and then empties returned, often in less than a week. This combination of product and attitude led to the germ of the brand idea: 'fresh'. The idea that a company produces and distributes fresh water is hardly inspirational. But if the emphasis of 'fresh' is not on the product, but on the service the business offers, it takes the idea down a far more interesting route. The idea became descriptive of a fresh attitude and a fresh organisation, rather than a fresh product.

The strength of the repositioning lies in the potential it gives the client to compete not only with the beverage sector (other bottled waters, as well as Coca-Cola and 7Up and so on), but also to make a leap into the business services sector, comparing it with such brands as FedEx. Every brand needs an idea to drive it, one that is unique, simple and true, and that builds over time into a compelling brand story. 'Fresh' became the idea at the heart of the Powwow brand and business, around which everything else was based.

powwow ™

Cooler thinking.

0.1 branding water ↗

How do you build excitement around an everyday commodity that for most of us is too ubiquitous to be remarkable or even noticeable? How do you brand water?

This was the unusual challenge faced by Wolff Olins when devising a way in which to brand Watson's Water's water delivery service.

0.2 wells and springs ↗ ↗

The existing names of Watson's Water's UK acquisitions were drearily typical of a market dominated by 'wells' and 'springs'. Nevertheless, each business was growing rapidly and seen as successful in the field.

The role of Wolff Olins was to help Watson's Water develop its leadership position by devising a successful brand idea, once it had integrated all its several businesses.

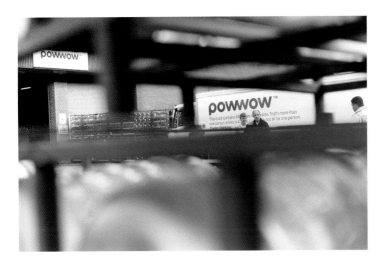

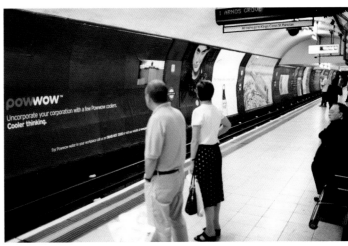

0.3 understanding ↑ ↗

'As with all of our projects, we started by researching the market and understanding the issues faced. As well as conducting primary research among consumers and business customers this also meant travelling around on the delivery trucks. Our research included sixteen hours of video footage worthy of Andy Warhol, showing people using water-coolers.

'It soon became clear that most consumers had little or no opinion: "nobody expects much from water or thinks much about it", "it offers few disappointments and has no real enthusiasts". We were faced with the exacting problem of how to build a brand around something as apparently invisible and taken for granted as water.

'Throughout our considerations we kept in mind that for consumers, "it's only water". We looked at ways that the brand could make the experience of water consumption in an office environment more meaningful, without trying to hype up the product itself.' – Wolff Olins.

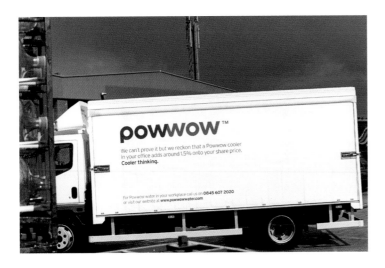

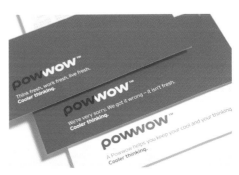

Wolff Olins believed that the aspirations of the brand were best met by choosing a conceptual rather than geography-based route to naming. This was also supported by the strategic decision to move the brand out of the world of water and into the world of business services.

0.4 differentiation ↑ ↗

The brand name had to be recognisable, memorable and pronounceable. It also had to be fresh and significantly different from the rest of the water-cooler market. Research demonstrated that Wolff Olins could safely move away from a location-based name without losing customers.

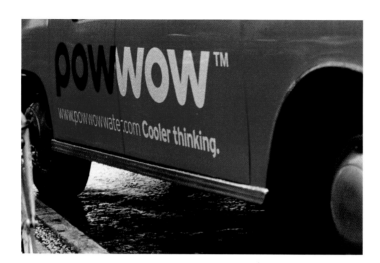

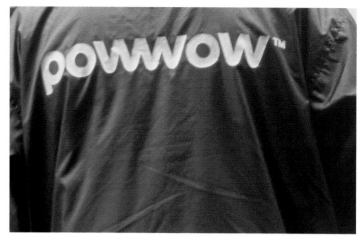

0.5 an emotive name ↑ ↗

Powwow – a meeting for discussion among friends or colleagues – is an emotive concept defined by talking. The name articulates the paramount importance of communication. It conveys the idea of a company that is always talking with customers and employees to find new and better – 'fresh' – ways of doing things. Powwow is an unusual and unorthodox solution, and Watson's Water's acceptance of this recommendation demonstrates the company's open-mindedness and foresight.

0.6 making the mark ↖ ↓

With an idea based around a service ethos and a brandname radically different from the market norms, Wolff Olins' designers pushed convention by creating a mark in rubine red and purple, rather than the familiar blue and green palette typical of the industry. In asking 'had we gone too far?', Wolff Olins was convinced that any compromise would only serve to detract from the distinctive idea and nature of Powwow.

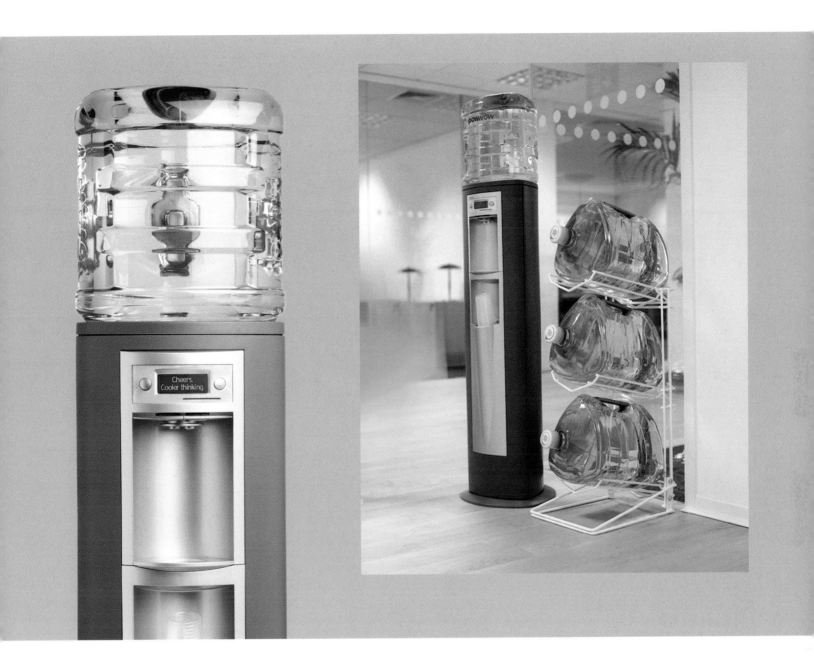

0.7　cooler design　　　↑　　↗

A key part of the thinking behind the Powwow brand was how the cooler could be brought out of the corner. Starting with the concept of informal conversations around a water-cooler, Wolff Olins wanted to give the customer a modern machine that could occupy a more central place in the office. And this was a vital element in creating the sense of friendly informality that is at the heart of Powwow. After spending hours observing how people used water-coolers, Wolff Olins worked with Watson's Water to devise an innovative design that incorporated new technologies, enhanced ergonomics and a modern integrated style.

In addition, they applied the idea of 'fresh' throughout the company, from the design of the delivery personnel's uniform – urban, smart and black – to the design of the central support office – glass-walled rooms and open informal spaces.

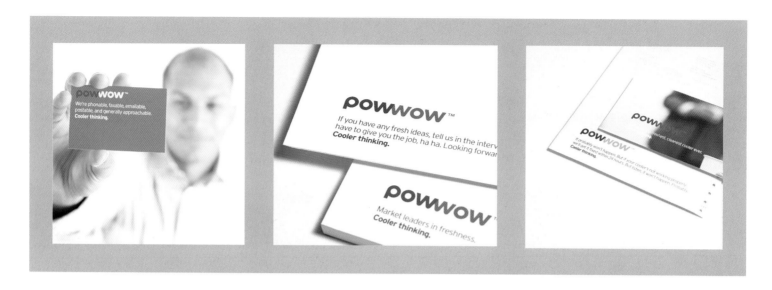

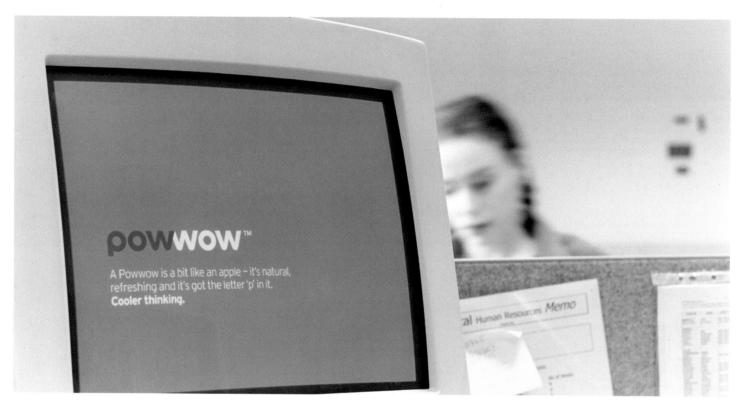

0.8 talking water ↗

Another distinctive element in the Powwow brand is the language it uses. The intention was to create a brand for a large organisation that talked and acted like a much smaller one, giving the company a culture that stays close to its customers and provides a highly personalised service. So Powwow communications use an informal tone of voice and introduce humour with a light touch.

'For us, a successful brand is all about detail. Every facet of the brand must be apparent in an organisation's communications,' comment Wolff Olins.

The delivery trucks, the website, the company stationery: everything carries messages that either raise awareness of Powwow or communicate the service promises.

0.9 making fresh credible ↗

Launching the new brand was about much more than announcing a new and unusual name. If the brand idea of 'fresh' was going to have credibility, there had to be clear evidence of real innovation in operational practices. At the internal launch – the first time that every employee of the new organisation had ever been together in one room – a number of business changes were announced at the same time that the brandname was revealed.

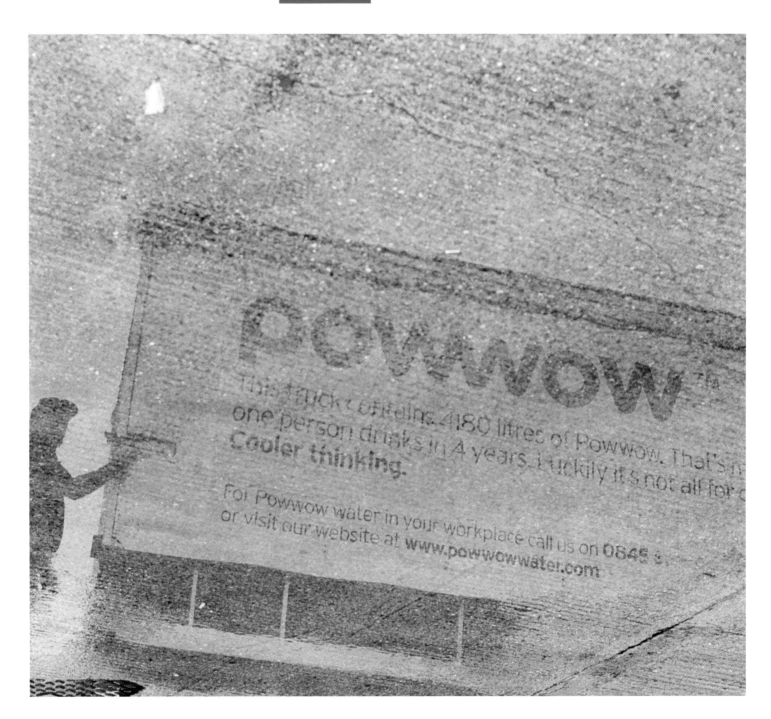

1.0 future fresh ↗

Powwow has rewritten the conventions of the water-cooler business and has been successful with customers. Since its launch in July 2000, its sales have increased by nearly 55 per cent, making it the clear market leader. The realisation of Watson's Water's ambition to move into mainland Europe has also begun: Powwow has been launched in Belgium and Germany with plans for other countries in the near future. Giving tangible evidence of how the company was going to change demonstrated the company's commitment to the idea and attitude of taking a fresh approach to everything, from business development to customer service.

The Tate & Lyle Soft Drinks Report of 2001 announced Powwow as the top new soft-drink launch of 2000 by volume (beating products by Volvic, Robinsons and Britvic). The report commented that 'Powwow's significance lies not only in the designer nature of its image, but also in the choice of a social positioning rather than a source.' The same report places Powwow as the second biggest-selling British water brand.

Also within the first twelve months of launch, Powwow became the fourth largest bottled-water brand in the UK by volume, including all consumer and retail brands.

project 0.7 levi's®

Recent years have seen a consumer drift away from established denim-wear brands such as Levi's®, Lee and Wrangler to a more disparate base of manufacturers. Designer labels such as Tommy Hilfiger, Calvin Klein, Diesel and DKNY, and smaller independent manufacturers, have been steadily acquiring a greater share of the market. Many of these brands do not focus solely upon denim products as their main commodity, and in fact their denim-wear lines are often incidental to other clothing products. It is the character of distinction, the individuality of exclusive lines, and the perception of credibility through association with the parent label that precipitated the diversification of consumer choice.

Levi's®, arguably the most renowned name in denim-wear, reacted positively to the shift in consumer behaviour, opting to reinvigorate their product by expanding their lines and producing styles that not only reflected emerging trends, but drove them (for example, the highly successful twisted-seam line). In 1999, London-based design agency the Kitchen began working with Levi Strauss Europe, Middle East and Africa to carry through the reinvention of the Levi's® brand image. This rebranding exercise looked beyond the consumer, aiming to raise the profile of the new brand through the press, and to educate merchandisers at various Levi's® retail outlets about the new visual direction and expectations of the brand.

The campaign consisted of a series of limited run books and other promotional tools, which made extensive use of unusual materials and experimented boldly with formats. The books' themes reflected the nature of the particular product that they were promoting. For example, the LEVI'S® VINTAGE CLOTHING press book featured earthy, muted colours and individually hand-distressed covers – a technique used on the product; the premium line book featured an embossed leather cover and quality stock; the Levi's® RED™ press book's shard-like pages reflected the glass-texture style of a particular denim finish. Other promotional tools included a 1960s' pastiche of a photograph wallet – the contents referenced Andy Warhol's famous Factory scene, which was a direct influence on the product featured.

The dissemination of the new brand language was controlled by Head Office in Brussels, but its manifestation in Levi's® outlets was individualised and varied. Due to the unique and bespoke nature of the variety of retail stores around the world, merchandisers have the freedom to dress their environments in a style appropriate to their particular store. The promotional material distributed among Levi's® outlets acted as a 'brand shepherd', encouraging creativity and providing inspiration through the experimental nature of the formats, materials and contents, without being prescriptive and inflexible. Consistency of message was achieved across all territories, while maintaining a fresh, dynamic and innovative approach to the marketing of the brand.

Page Eighteen 2076

Levi's® RED™ Midday/Midnight

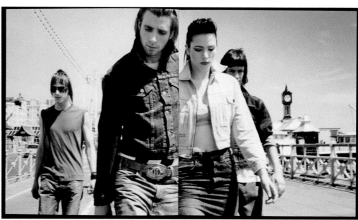

0.1 vintage ↗

The LEVI'S™ VINTAGE CLOTHING spring/summer 2002 press book has a matt black foiled cover that is then individually hand-distressed – a technique normally applied to clothing. The bespoke feel of the cover complements the individual nature of the season's product lines.

0.2 glass ↙ ↙

The Levi's® RED™ autumn/winter 2001 press book mirrors the inspirational glass theme of the clothing. The complex six-sided box contains a series of thick shard-shaped boards showcasing key signatures from the RED™ product line.

0.3 originals line books ↗

The 2002 originals line books are created out of card, and feature die-cut holes referencing elements of the new store interiors.

0.4 red ↙

The Levi's® RED™ spring/summer 2002 press book has a strong 'rock 'n' roll' theme, inspired by the clothing of the season. A metallic cover (reflecting the copper chains used in that season's clothing) with matt black foiled lettering contains pages that ingeniously spiral around the spine. The press book interprets the skewed appearance of the product to create an effective and innovative piece of print.

0.5 originals line books ↖ ↗

Above are adhesive stamps applied to the cover of the originals line book – complete with Levi's® franking stamp.

Eclectic 'lightbox' typography is used on the brochure for the European launch of the spring/summer 2002 clothing range.

0.6 premium line ↗ ↓

Embossed leather-look premium line book for Levi's® RED™ and LEVI'S® VINTAGE CLOTHING from spring/summer 2002 distributed in heavy card packaging. The internal graphics and photographic usage have a journal-like and personal quality.

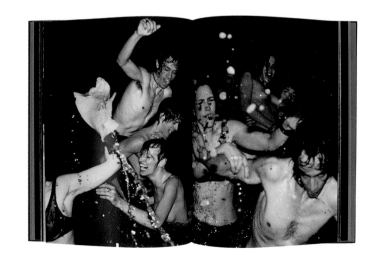

0.7 originals line books ↑ ↘

Despatch packaging graphics are applied to both the original and the premium line books, which contain all the products for the coming season.

Plastic-encased carbon delivery documents, card dividers and ubiquitous brown packaging create a convincing pastiche of utilitarian graphics.

0.8 originals line books ↓

The summer 2000 concepts brochure uses blueprint-inspired graphics combined with photographic visual summaries of the product ranges under semi-transparent dividers.

0.9 dummies ↑

Crash test dummies are used in preference to traditional models through-out the summer 2000 premium line book, creating a distinctive industrial feel and referring to the protective nature of the clothing.

1.0 press tool ↑ ↓

LEVI'S® VINTAGE CLOTHING press sendout in the guise of 1960s' photographic packaging. Perforated 'Bonus Prints' allow for dual usage of the imagery, and the sendout also incorporates hand notations on the photography, randomly placed stickers and even coffee-cup stains.

Included in the pack are a series of text cards. These contextualise the package with information on subjects from women's liberation to Pop Art.

1.1 vintage

On a theme of 'light', the spring 2001 VINTAGE CLOTHING brochure arrives enclosed by a blank film strip. Within the spreads, light projections are used in preference to flat typography, creating breaker-pages.

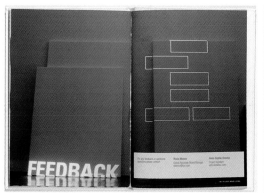 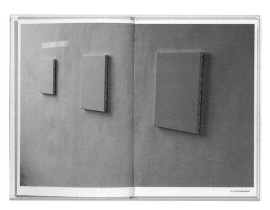

1.2 premium line

The psychedelic imagery, Andy Warhol Silver Balloon-inspired covers and bold typography of the LEVI'S® VINTAGE CLOTHING autumn 2001 premium line book are evocative of 1960s' Pop culture-inspired clothing.

 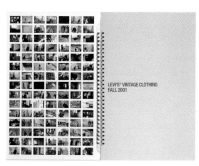

1.3 brochure ↗

An intentionally unpretentious magazine insert for LEVI'S™ VINTAGE CLOTHING is distinctive when seen in the 'glossy' surrounds of the style magazines into which it is inserted. The simplicity of the typewriter message, 'Blank Canvas', invites the reader to interpret the products in an individual manner. The 'blank' exteriors of the pocket-sized brochures conceal expressive spreads where examples of distressed clothing, by artists and members of the public, form the content.

1.4 poster ↘

A series of accompanying posters were used as marketing tools, featuring products customised by emerging written-word artists.

project 0.8 IBM

The e-business revolution of recent years has provided fertile and uncharted new territories for business, brands and design. As business has exploited e-commerce opportunities, so too have the design and marketing fields of branding and communication, utilising the very media through which e-commerce is channelled to expand the scope and remit of their disciplines.

IBM commissioned Imaginary Forces, the L.A.- and New York-based multimedia design agency, to reposition the corporation in order to target the new audience that had arisen from the proliferation of new digital products and services in this field. This needed to be achieved while leveraging the huge amount of marketing money previously spent communicating the brand. The desired result would be to have IBM established as a 'thought leader' and innovator within this new market.

IBM's Chicago branch of its Centers for IBM e-Business Innovation achieves this aim, and is a prime example of the successful combination of business and design to promote the potential of e-business. Designed and orchestrated by Imaginary Forces, together with interior architects and IBM Marketing, the Chicago Center is a showpiece of high technology and innovative spatial design.

The purpose of this specially designed environment (one of several in major cities worldwide, including New York, Hamburg, Tokyo and Sydney), is to allow senior management teams to come together with IBM and its alliance partners to define, create and manage e-business solutions. It consists of a series of rooms and theatres punctuated with video and projection walls and interactive kiosks. Interactivity is the linchpin of the entire experience. With screens that can be personalised, a soundscape that responds to the proximity of the visitors, and architecture that reconfigures itself (through mechanically manoeuvrable walls that allow for individual or group experiences), content and environment merge seamlessly.

The environmental experience – be it brand centre, visitor centre, showcase, event – is the expansion of the brand into broader territories, where urgency and immediacy give way to explanation and elaboration. The clients have chosen a particular brand among all others, and have bought into its philosophy. They have chosen to visit the space at their own discretion, and now require a demonstration of what the brand can do for them. This is not the highly overt competition and clamour of above-the-line branding. It is an intimate discourse, where the brand must perform, convince and deliver. This is a point at which the 'core meaning of the modern corporation' (Klein, *No Logo*) can be effectively articulated and amplified.

In the case of IBM, it is 'the digital' that is the core of the brand. It underpins the universally recognised 'eight-bar logo', which references the eight-bit basis of modern computers and evokes the look and feel of a monitor screen. It is the *raison d'être* of the corporation, which not only manufactures computer products, but also educates other businesses about the advantages of electronic commerce. It also emphasises the way in which IBM projects itself to its clients. Visitors to the Chicago Center find their experience enhanced by digital technology, are convinced by the expertise of the corporation, and are left in no doubt as to IBM's dynamic and foremost position in the contemporary landscape of e-business.

The Chicago Center is the epitome of digital innovation, and the embodiment of the fundamental values of IBM, encapsulated in the words of former IBM CEO Thomas Watson Jr., 'Good design is good business'.

Photograph by Benny Chan

0.1 design team and technical skills ↑ ↘

'A multidisciplinary team assembled by Imaginary Forces closely integrated architecture, media, music, industrial design and technology into a holistic design approach. Designs, sketches, motion tests, models, schematics and music cross-pollinated into an approach that embraced diversity. A close dialogue between Imaginary Forces, Design Office and IBM Marketing ensured an exceptional result.' – Mikon van Gastel, Creative Director at Imaginary Forces.

'The team was relatively small and comprised of designers who were truly multifaceted – we had animators who could work in 2D and 3D, as well as designers who could work in code (OpenGL, Java and Director). A lot of the experiments (especially in the "discovery phase") came from different sources, and as we narrowed down the approach we figured out the best tool to do that aspect of the job. It is important to note that for most of these pieces we were hiring writers, designers, technologists and producers, most of whom were overlapping both titles and work, so that all the elements of the content were coming from the same core. I was surprised to see how much it showed in the final project – it just all seemed to make sense.' – Matt Checkowski, Art Director at Imaginary Forces.

:: reception

:: interactive kiosk

:: lounge

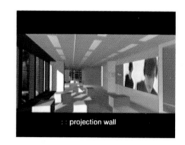

:: projection wall

:: theater wall open

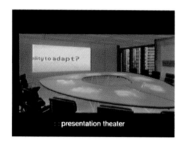

:: presentation theater

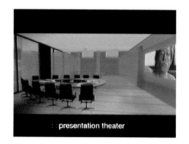

:: presentation theater

:: interactive table

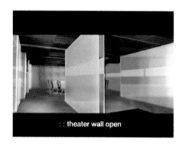

:: galley wall

:: galley wall open

Questions. Possibilities.

:: interactive kiosk open

0.2 architectural previsualisation – virtual tour ↗

A Quicktime fly-through of the proposal for Chicago's Center for IBM e-business Innovation allowed the designers to present a convincing vision of their solution before building began. The powerful rendering and animation capabilities of the Form-Z software package, within which the fly-through was created, enabled the visualisation of key aspects of the Center through accurate rendering of all substrates and inclusion of moving image.

The elegant reconfiguration of the glass walls, and the seamless integration of the images that they carry, are effectively described. So too are the interactive tables, whose multiple functions were illustrated as passive video screens, interactive interfaces or lightpen-sensitive keypads.

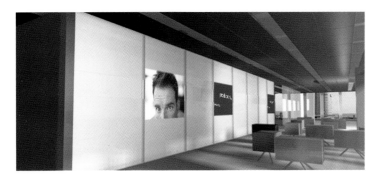 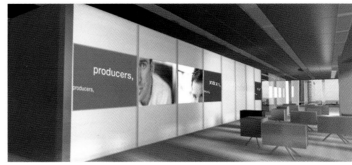

0.3 galley wall ↑ ↓

The galley wall consists of a series of projections onto glass panels that act as a backdrop to the refreshments area. The panels can move when required, to reveal the kitchen.

'The galley wall is driven by eighteen slide projectors that project onto nine moveable glass panels/doors. After assessing what we wanted to accomplish on this surface and what the budget allowed for, we went with the slide projectors and a stop-frame animation of typography and image. We hired a still photographer to shoot real (!) IBM employees in a manner that referenced the space that the slides were going to be projected on.

'From there, we selected the still frames and brought them into AfterEffects, where we previsualised the nine-door setup and could see how the images would move across the glass surface. A file was created and the information was fed into the computer that controlled all of the projectors. The whole programme ran for about ten minutes and then looped. The most amazing thing about this surface to me was the organic nature of the film – the majority of out media was digital, and the organic and warmer nature of the projected slides really stood out,' explains Matt Checkowski.

0.4 skywalls – content ↓ ↘

The skyline walls appear in the theatre, and consist of short movies projected onto moveable glass panels. Each movie features a city in which IBM has a Center for IBM e-business Innovation. The captions that punctuate the visual backdrop of the movies juxtapose facts from the real world with those from the realm of cyberspace.

For example, the Sydney section compares the population of Australia in 1932 (6,501,000) with the population in the year 2000 (19,167,083), and makes the point that 7,600,001 Australians were surfing the net in 2000 – more than the entire population of the country when IBM arrived in 1932.

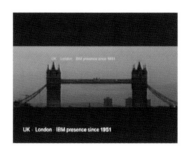

0.5 skywalls – technical ↓ ↘

'The skyline wall films are a combination of footage that we shot with international crews, stock footage and statistics that we researched and/or created.

'After designing the ideas and storyboards in Photoshop and Illustrator, we hired film crews in Sydney and London to shoot a variety of elements in each city on Super16mm. New York was all stock footage.

The London section juxtaposes the number of inquiries that the staff of the Houses of Parliament handle in a day (almost 7,000) with the number of inquiries that its website is capable of handling (almost 50,000).

These comparisons indicate the magnitude of traffic on the internet, its massive potential for trade, and also the size of the task faced by businesses in order to succeed in e-commerce.

'The elements were then edited in Avid, transitions designed in Cinema4D, and the piece finished in Flame at HiDef.

'The statistics are humorous facts that, combined with the image that is behind it, create juxtapositions of e-business and the real world. The final hardware setup is exactly the same here as in the branding animations, although the skyline wall has a sensitive sound component to it. Each film has a built-in soundtrack/sound-design element that senses proximity and changes when you come close to it. The soundtracks were composed by Musikvergnuegen. The sound and the Center soundtrack was designed in ProTools,' comments Matt Checkowski.

0.6 questions video ↑ ⬈

The questions video appears in the Presentation Theater and features multilayered animations of text and ambient graphics. The text asks pointed questions such as 'Are you the same brand wherever your customer finds you?', 'Is your strategy designed for a static world or a changing one?' and 'How can you give customers more than they expect?'. The animations reflect the text's essential themes of dynamism, flux and transience in the world of e-commerce.

The questions are relevant to the concerns of clients, and persuade them that IBM not only know the questions before they have asked them, but that they have the answers, too, and that they are embodied in the very essence of the Center.

Mikon van Gastel remarks, 'The questions video is a great example of our multifaceted team. We did early designs in After Effects and Cinema4D but nothing was really working the way that we wanted – it was a major problem to update the text (which was still to be written and approved by both us and IBM), and the motion wasn't really right. Imaginary Forces designer Peter Cho solved this whole thing in OpenGL – it's all done in code. We brought together each section and did the colour in Flame just to add some finishing touches.'

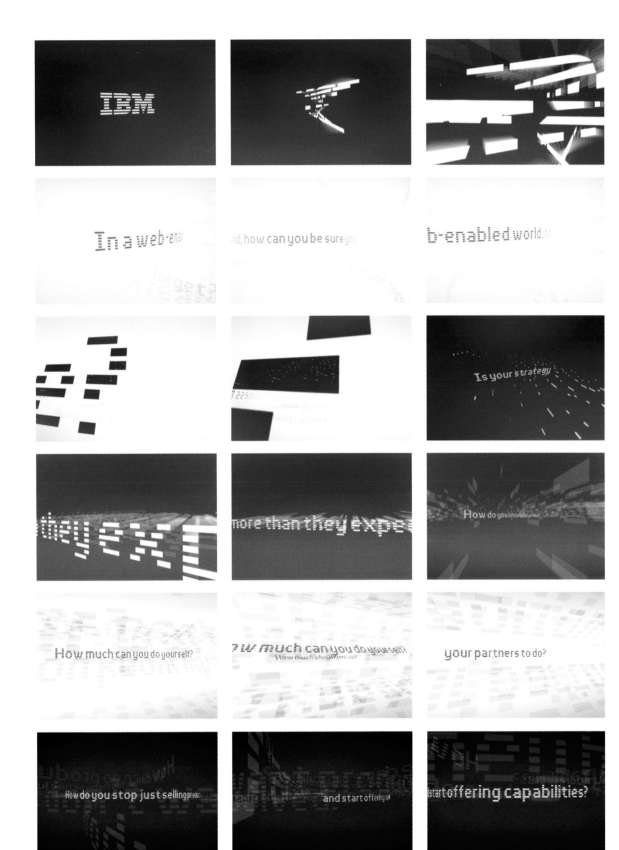

0.7 brand animations ↗

IBM's distinctive logo was created by the renowned and respected American designer Paul Rand. Possibly his most recognised design, it appeared in 1956 and consisted of the letters IBM rendered in a specially drawn typeface called City Medium. The logo was modified by Rand in 1972 and has remained essentially unchanged until the present day.

Whereas many identities have struggled to adapt to today's screen-based media, Rand's logo has a malleability and versatility that has allowed it to translate successfully to moving image and digital media. As demonstrated above, the logo's slab serif letterforms belie their megalithic inertia through open and dynamic horizontal movement – afforded by the eight parallel lines from which they are constructed. These lines lend themselves to deconstruction and movement in space, as realised by Imaginary Forces in their branding animations for the Chicago Center.

0.8 interactive tables ↙ ↘

The inspiration for the table came from something Imaginary Forces' client, Howard Fields, said early on in the process: 'The key to becoming a successful e-business doesn't just lie in new technology: it lies in new business processes, new attitudes and new cultures.'

This statement rings true within the IBM Centers. A fully functional and elegant interactive table reshapes the traditionally hierarchical sales model. The primary tool for bringing clients together with IBM topic specialists, the table is a surface where participants interact and manipulate ephemeral, digital projections while seated in a configuration that encourages collaborative dialogue.

0.9 virtual tour – modules ↙ ↘

The virtual tour modules are vignettes of a cross-section of IBM Center employees. The modules' use of employees of both sexes, and of many ages and races, demonstrates IBM's inclusive and all-encompassing approach. These 'talking head' pieces expound the values of IBM through the intimate knowledge of its own employees. This human aspect complements the hi-tech, cutting-edge feel of the physical environment and the direct verbal communication adds warmth and inspires trust.

'We shot all of the movies [modules] within the virtual tour on Super16mm, edited them in Avid, and finished them in Smoke, because it was strictly editorial compositing and there was very little designing at that stage. We worked with IBM to create scripts and locations that would cater to both the individuals in the films and the messages IBM wanted to communicate,' says Matt Checkowski.

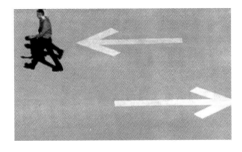 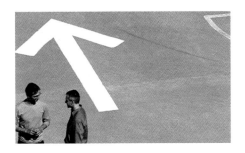

1.0 virtual tour – interface ↙ ↘

The virtual tour interface is integral to the interactive kiosks. Through the interface the client can access various aspects of the tour, such as strategy, marketing and technology, and through the modules can experience personal accounts from IBM employees, as to how they fulfil their roles in these areas. As Matt Checkowski explains, 'The virtual tour interface was initially done in OpenGL [the cross-platform industry standard language for development of 2D and 3D graphics applications]. We loved the transparency and the speed of it. The aesthetics are really nice. After going through all of the testing necessary, with an application that needs to live in a maxed-out theatre *and* a clunky laptop, I think everyone appreciated the result so much more. The functionality was just as impressive as the look and feel.'

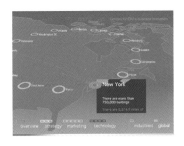

1.1 brand animations ↑ ↗

Further brand animations that punctuate the video content continue the theme established by the revamping of the IBM logo, utilising the horizontal motif and making creative use of four-dimensional space. Although these incidental animations predominantly express the unique character of the Chicago Center, they also reflect the essence of the IBM identity.

'The branding animations live on three video cubes (seamless television screens) that are driven by three DDRs (digital disc recorders), one per cube. The animations were edited and designed in After Effects and Cinema4D to a final size of 600 x 2,400 pixels, and finished in Flame. The finishing process involved dividing the animations into three segments (left, middle and right), one for each cube and DDR pair,' says Mikon van Gastel.

project 0.9 NIS

'The first stage of the design process was spent researching competitors and the client's marketplace in the UK. It became quickly apparent that competitors were few, based on the specialist nature of the business.' – Jonathan Ellery, Partner at Browns.

So why the need for an identity? The National Interpreting Service, or NIS, are a UK-based translation service, providing live telephone translation in more than 140 languages. This particular brand is almost unique in the UK, and in the absence of a competitor, we may believe that it has little need for an identity. But a branding programme not only serves the function of raising a product's profile in order to sell more than its competitors (see Coca-Cola pp. 142–145), or of providing a unified identity for a variety of different services (see connexxion, pp. 10–23). It can also help to signal the existence of the brand, to make its presence and function known to people who may benefit from it.

When UK design agency Browns began to develop the identity, they responded to the fact that NIS is a service that has no physical commodity. As the service is based solely on words and spoken language, it became clear in initial designs that a logotype rather than a graphical symbol would become the essence of the identity. Early brainstorming ideas looked at an 'Accident & Emergency' language, rendering the initials NIS as 'November Iceberg Sierra', in the Radio Communications Agency's phonetic alphabet. This approach suggested that the NIS was another emergency service, but was considered too specific and not flexible enough for corporate business clients. NIS had no wish to be pigeonholed. Additionally, a secondary identity would need to be developed to establish the real name of the NIS for the benefit of new clients, which would mean the identity would not work efficiently.

Other ideas encompassed visual typographic puzzles that deliberately courted ambiguity and confusion. Again, this route could be seen as inefficient and ineffective. But the requirement on the part of the viewer to decipher the language and engage with the identity was favoured by Browns. This was seen as unusual in a contemporary corporate identity and was incorporated into the final design.

The final identity for NIS is simple, concise and immediate. The use of accents and other pronunciation symbols from a variety of languages serve to visualise sound, and subtly convey the purpose of the service without over-elaboration. The symbols also serve as graphical elements, enlivening with movement and humanity what may have been merely the pedestrian presentation of basic letterforms. And a passing muse on the literal pronunciation of the letters with their grafted accents provides a moment of diversion and amusement.

In its fifteen-year existence, NIS had no coherent identity. The focused use of a limited budget provided a solution that is articulate and instantly recognisable. The provision of a clear, accomplished corporate identity overhauls the previous image of the NIS, providing it with the countenance of a professional, well-organised service, and a visibility and profile that was previously lacking.

'Browns have designed a mark that requires little explanation. Its wit and simplicity are its beauty. Browns have positioned us perfectly.' – Mark Kiddle, Managing Director at NIS.

ABCDEFGHIJ
KLMNOPQRS
TUVWXYZ

National Interpreting Service
1 St Clements Court
London EC4N 7HB

Telephone 020 7626 0220
Fax 020 7283 3678
E-mail NISUK@aol.com
www.nisuk.co.uk

M U B WF
PG Y TA EH
J O V QZ C
RK XD L NIS

MUBWFPGY
TAEHJOVQZ
CRKXDLNIS

National Interpreting Service
1 St Clements Court
London EC4N 7HB

Telephone 020 7626 0220
Fax 020 7283 3678
E-mail NISUK@aol.com
www.nisuk.co.uk

M U B WF
PG Y TA EH
J O V QZ C
RK XD L NIS

MAKING
SENSE

NIS

MUBWFPGY
TAEHJOVQZ
CRKXDLNIS

0.1 development ↗

A preliminary idea that came close to being adopted as the identity used
colour to distinguish the initials NIS from a nonsensical jumble of letters.
The strapline 'Making Sense' indicated the nature of the translation service,
but failed to clarify it.

**Nåtiønàl
Intérprẽtinğ
Sërviçê**

One St Clements Court
London EC4N 7HB

Nearest tube: Monument or Bank

Telephone 020 7626 0220
Fax 020 7283 3678
E-mail enquiries@nisuk.co.uk
www.nisuk.co.uk

The National Interpreting Service
is a limited company registered
in England and Wales Number 3806844

**Nåtiønàl
Intérprẽtinğ
Sërviçê**

National Interpreting Service
One St Clements Court
London EC4N 7HB

Nearest tube: Monument or Bank

Telephone 020 7626 0220
Fax 020 7283 3678
E-mail enquiries@nisuk.co.uk
www.nisuk.co.uk

With compliments

**Nåtiønàl
Intérprẽtinğ
Sërviçê**

National Interpreting Service
One St Clements Court
London EC4N 7HB

Nearest tube: Monument or Bank

Telephone 020 7626 0220
Fax 020 7283 3678
E-mail mark@nisuk.co.uk
www.nisuk.co.uk

Mark Kiddle
Managing Director

0.2 final identity ↗

A bold, simple colour palette of red and white reinforced the directness
of the identity. Consistent use of the final logotype across all media,
from business cards to letterheads, provided an unambiguous and
uncomplicated brand identity.

project 1.0 knoll

It is understood that a brand must have a high recognition factor, and must conform to comprehensive and often rigid visual guidelines in order to maintain this recognisability – especially when distributed throughout the world, and its visual identity passed through the hands of a variety of different design agencies. But this rigidity often stifles creative flair, and many brands can appear cold and lacking in personality. This may be appropriate and desirable for a corporation that wishes to project a clinical, serious and disciplined front. But for a company striving for recognition in a competitive industry, it is the personality and character of the brand that can often raise its profile above the mundane.

Knoll are renowned for their beautifully designed office furniture, and place great importance on their technical and aesthetic prowess. In the approach to Knoll's sixtieth anniversary celebrations, NB: Studio were asked to reinvigorate the brand. Knoll felt that the design agency's clean, contemporary style resonated with its own philosophy of combining functionality with superior design. Other furniture producers such as Ikea, Habitat and Interiors bis (see pp. 36–43) similarly utilise the bold, uncluttered qualities evident in the Knoll brand, this being both synonymous with, and complementary to, their products. But through the use of wit and artistic licence, and an open-mindedness on the part of the client, NB: Studio were able to move the Knoll brand away from the stereotype of the contemporary furniture company.

Personable values of charisma and informality were communicated through whimsical and adventurous use of the well-known Knoll logo. Assumed rules of logo usage were dismantled in favour of an affectionate and flamboyant treatment. A ribbon was added to the logo in Christmas literature, various colour treatments were applied across print and web media, the name was punned in the 'Knolledge' quarterly, and the letter sequence was totally deconstructed in the 'Big Red Letter Day' material. The resurrection of Herbert Matter's 1958 logo, as a feature of the sixtieth anniversary poster series, reinforced the brand's pedigree, acknowledging and embracing the company's assets of heritage and authenticity.

The decision to forego the use of photography in the majority of designs was dictated by budget restrictions. But this allowed NB: Studio to project the brand through a more considered, less product-orientated approach. The confidence of a brand to trade on name and personality, regardless of the product, assumes a prior understanding of the brand in the mind of the consumer, and is an indication of the strength of its identity. This makes a more sophisticated communication possible, through aspirational and emotive values. Warmth and humour combine in the Knoll brand to project values of geniality and approachability, while the bold and unpretentious visual identity communicates the importance that the company places on design. The success of the brand can be attributed to both superior product and to the effective communication of its values.

The axiom 'Good design is good business', attributed to former IBM CEO Thomas Watson Jr. in the Imaginary Forces section of this book (see pp. 84–97), is also attributed to Florence Knoll, associate of the company and wife of founder Hans Knoll. Regardless of the originator of the phrase, the fact that it is attributed to the figureheads of two disparate but highly successful companies reinforces the importance of the role of design in business, and emphasises that effective brand communication is essential to commercial success.

nb: studio

knoll

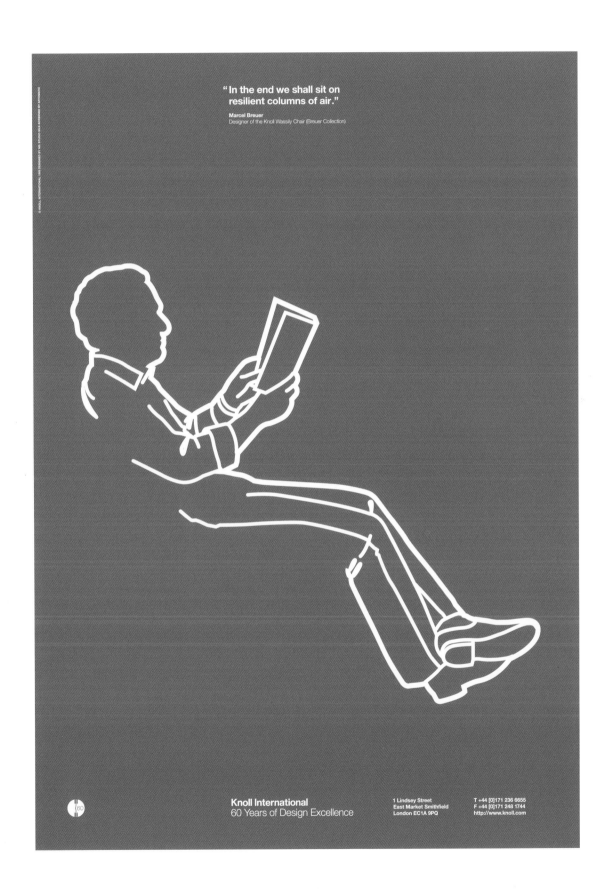

"In the end we shall sit on resilient columns of air."

Marcel Breuer
Designer of the Knoll Wassily Chair (Breuer Collection)

Knoll International
60 Years of Design Excellence

1 Lindsey Street
East Market Smithfield
London EC1A 9PQ

T +44 [0]171 236 6655
F +44 [0]171 248 1744
http://www.knoll.com

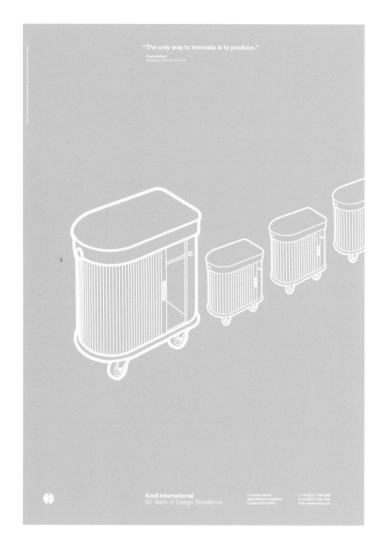

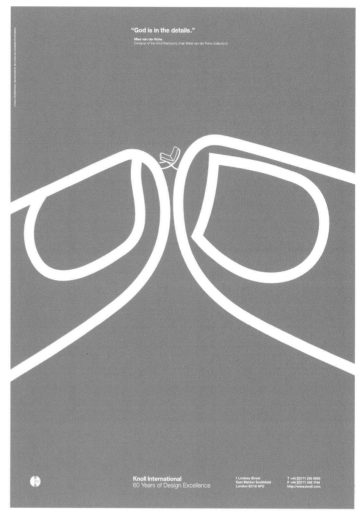

0.1 knoll classic poster series ↗

'The Classic posters were originally commissioned as a series of six full-page ads to run bi-monthly in *Blueprint* magazine. After the success of the campaign and frequent requests they were silk-screened at A1 size and used in Knoll showrooms and dealerships throughout Europe. They have since been used as postcards and frequently reused as ads in Europe.' – Ben Stott, Designer at NB: Studio.

A budget restriction on the commissioning of photography, which could be viewed as a hindrance to the communication of a brand which sells furniture, actually allowed NB: Studio to develop a highly recognisable illustrative style. Representing products as white line art on flat colour emphasises the elegant forms of the furniture, while the designers' quotes at the top of each poster provides a light-hearted, humorous quality.

'The initial decision to use line art was budget-based – there was no money for nice photography – plus we also wanted to do something different for an ad in a magazine full of pictures of chairs,' comments Ben Stott.

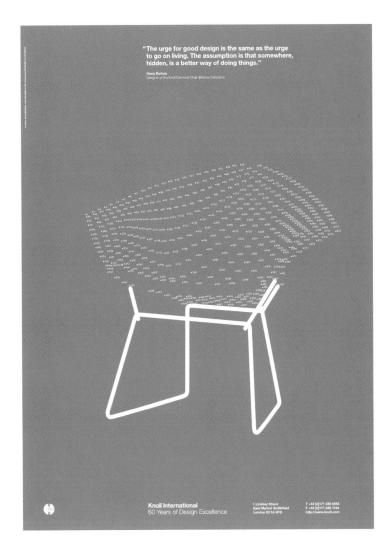

0.2 knoll diamond chair (bertoia collection) ↑

In this imaginative representation of a Knoll product, the intersections of the mesh seat of Harry Bertoia's Diamond Chair are used as points upon which numbers are plotted. The effect resembles a 'point cloud' (a rendering option in 3D design applications), suggesting technical proficiency and cutting-edge technology.

But in fact the numbers simply count, in a join-the-dots manner, from 1 to 440, the number of intersections in the mesh. This association between poetic elegance and design know-how, and of the beauty within the functional, captures the essence of the Knoll brand.

"Compromise usually comes from
a fear of being pure."

Eero Saarinen
Designer of the Knoll Tulip Chair (Saarinen Collection)

Knoll International
60 Years of Design Excellence

1 Lindsey Street
East Market Smithfield
London EC1A 9PQ

T +44 [0]171 236 6655
F +44 [0]171 248 1744
http://www.knoll.com

"The swirls and curves of my chairs are
structural and they grow out of necessity."

Frank Gehry
Designer of the Knoll Cross Check Arm Chair (Gehry Collection)

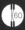

Knoll International
60 Years of Design Excellence

1 Lindsey Street
East Market Smithfield
London EC1A 9PQ

T +44 [0]171 236 6655
F +44 [0]171 248 1744
http://www.knoll.com

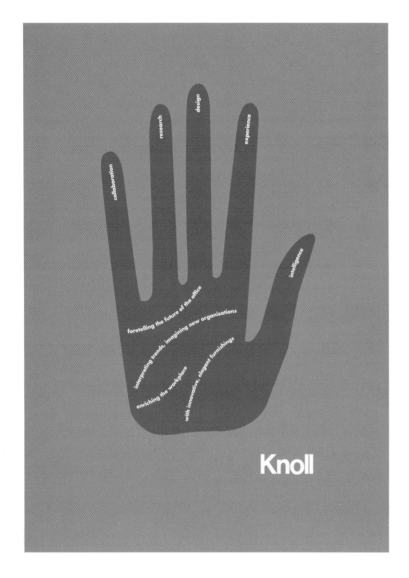

0.3 knoll spectrum poster series ↑

This series of posters progresses from the simple outline style of the Classic posters, to include more illustrative picture elements. The bold, flat colour continues to be evident, as does the use of humour. But visual reference to the product is almost totally eradicated.

This is partly due to the intended purpose of the posters, which was to complement the furniture at the Knoll stand of the Spectrum furniture exhibition in London, and subsequently for use at showrooms. But the strength of Knoll's visual identity allows for creative scope and experimentation, while maintaining brand recognition.

0.4 brand language

The content of these posters refers to the twin pillars of the brand's strength – technical proficiency and aesthetic excellence. The messages champion good design, and contend that the advantages afforded by technological progress are no substitute for the human element, e.g., 'Wireless technology is here, but don't pull the plug just yet', and 'Cyberspace is a reality, but it will never replace human interaction'.

Knoll are shown to both embrace technology, and to promote the ethics of design above all else.

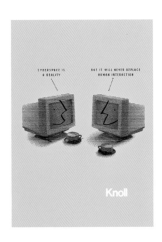

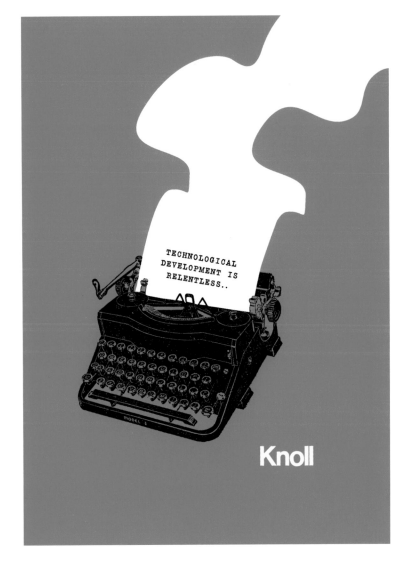

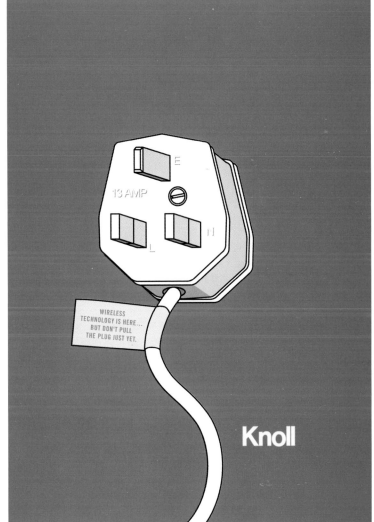

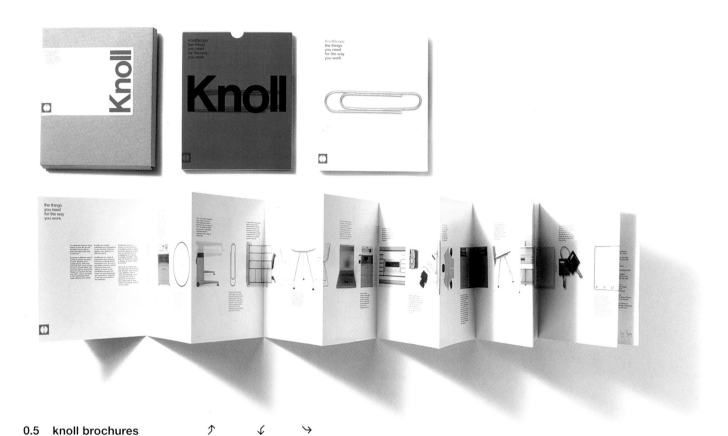

0.5 knoll brochures ↑ ↓ ↳

'Our designs are primarily for Europe, and many appear in four languages or are translated at a later date. Some product brochures and promotional posters have been used outside the European market.

'The Knollscope brochure was for a range of office systems furniture, which is based on a serviced wall, but goes down to items as small as a personal filing storage system. Hence the design, which is based on a choice/conveyor belt concept. No sizing scale is given so as not to give any one part of the system importance over another. It also talks about personal preference/importance, i.e., the most important thing in your office might be a paper clip!

'The Scope brochure was also designed with an unlimited number of languages in mind, so all four-colour imagery was kept separate from text. Image blanks were printed, and then overprinted in two specials. Languages currently run to eight,' explains Ben Stott.

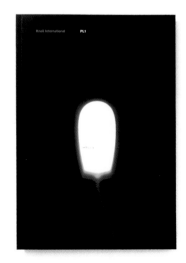

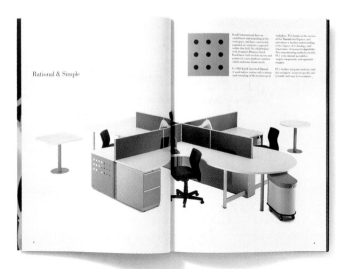

Homer

A key member of the PL1 product family is Homer a personal reference unit for the mobile workforce. Effectively a briefcase on wheels which can be pulled to a chosen worksetting. Homer provides two separate storage compartments. Behind a receding tambour door is space for personal effects and files, accessed from above is space for stationery items and a lap-top.

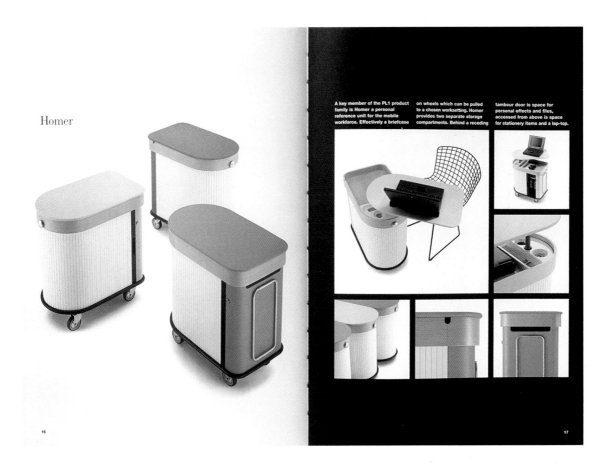

Kno*ll

0.6 knoll present logo ↗

With the simple insertion of a line, the Knoll logo is innovatively transformed into a visual pun on the notion of 'present'. Here is a good example of how a classic logotype constructed in the modernist typographic tradition is given a humorous twist, without degrading the integrity of the original mark.

0.7 knoll christmas card 1998 ↙

The 1998 Knoll Christmas card appears in the guise of a brochure insert, complete with punched holes, suggesting that it is part of a series. The content of the card presents an assembly guide for a sleigh under the heading, 'The Christmas Collection: Sleighs, accessories'. The logo on the cover is subtly modified to feature a ribbon, suggesting a wrapped gift.

0.8 racing invitation and table card ↗

This invitation and table namecard for a client day at Ascot features a period illustration of a horse and groom. A mischievous reference to the nature of the company can be seen in the substitution of the horse's hooves for casters!

'One of the many little jobs we enjoy doing for Knoll,' says Ben Stott.

0.9 binders ↙

Strong visual patterns are formed by wrapping the logo around three-dimensional items such as binders.

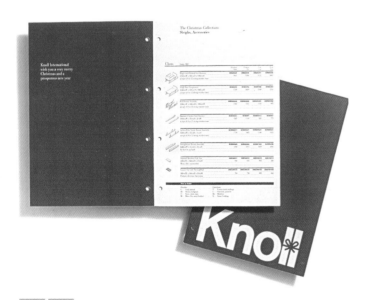

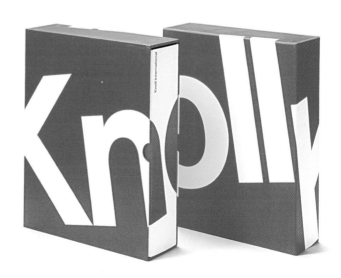

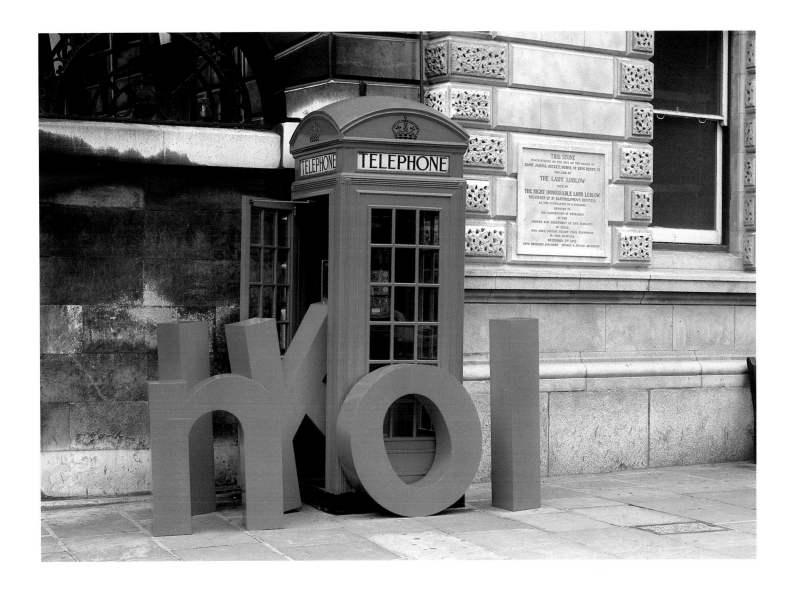

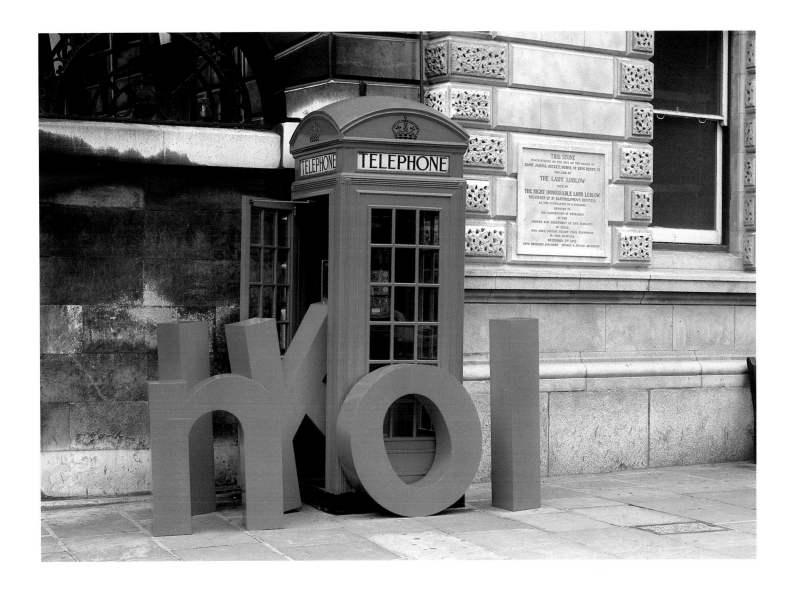

1.0 big red letter day postcards ↑ ↘

The key characteristic of this small-scale branding exercise – the rearrangement of the physical letterforms of the Knoll logo – was put to delightful and effective use. It played on the theme of 'red letter day', a British term for a memorably important or happy occasion. The campaign publicises the opening of a new showroom in London's East End. The letterforms were photographed in random formations at various locations in the vicinity of the showroom, each location being chosen for features that are associated with London – a red telephone box and a bus shelter. The resulting A5 postcard mailers were reproduced as posters for the showroom walls, and the letters themselves were placed in a jumbled order in the showroom window. The idiosyncrasies of this campaign ensured high recognisability within a specific vicinity, to a precisely targeted market.

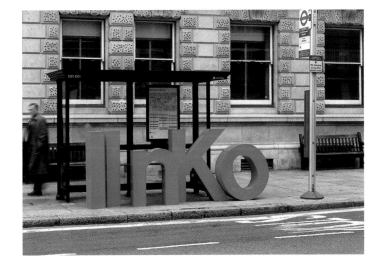

1.1 www.knollint.com

The Knoll International website is the European portal for Knoll, and is a separate entity to the US site, which has a single market and sells direct to its customers.

Knoll International is design- and information-led. This gave NB: Studio greater flexibility with the site's identity, which features large, bold type in strong flat colours, and simple monochromatic renderings of the products.

Small home users were ruled out in the initial meetings (those using 28kbps modems), which enabled the extensive use of graphic elements. But the flat colour and simple outlines of the graphics allow them to compress well, and facilitates the use of advanced java-scripting for interactive sequences.

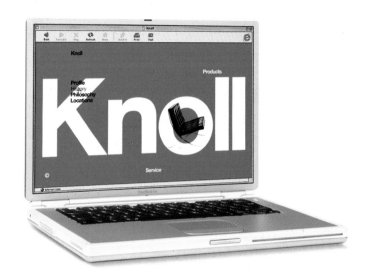

1.2 knolledge

Often overlooked, internal documents like the humble newsletter are given the same thought and consideration as more public-facing items. 'Knoll' (the brand mastermark) is merged with 'edge' (implicit of innovation) to form the new hybrid, Knolledge. The rationale with the newsletter is to standardise the typography in line with other items and to introduce the same stylised approach to illustration and colour usage.

1.3 twenty-first century classics

The Twenty-First Century Classics poster consists of an entire year represented by items of furniture, with for example, 5 April being depicted by Mies van der Rohe's MR armless chair. In isolation, each illustration is relatively simple, yet the sublime beauty of the poster is realised through the sheer volume of pieces shown and the painstaking detail applied.

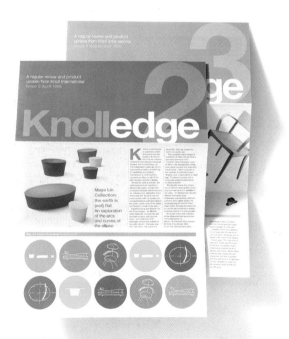

Knoll

Twenty-First Century Classics

project **1.1** ford of europe

For the twenty-fifth anniversary of the Fiesta family car, Ford of Europe required a press-only launch of the All New Ford Fiesta on the eve of the 2001 Frankfurt Motorshow. In order to attain the required attendance of 500 journalists from across Europe, and to reflect the status of the motoring giant, Ford wished to set a precedent by which future press launches would be measured.

PCI LiveDesign, the London-based events and exhibitions agency, were appointed to design and produce the launch and the unique club concept behind it, while also seamlessly accommodating several brand identities within the event – those of Ford, the Fiesta vehicle and the identity of the event itself.

The launch and the publicity leading up to it was to be branded 'Blu', a theme that reflected the 'blue oval' brand of Ford and the pan-European scope of the target market, 'blu' being a word specific to no European language but recognisable to all. To indicate the prestige of the forthcoming event, an exclusive club was created, which journalists were invited to join, and which would be an umbrella for future Blu events. The name, 'bluovalclub', was designed to reinforce the association with the parent brand, without suggesting that it was a broad-based Ford club. A website was established three months prior to the event through which journalists would register for membership of the club. This established the theme of the event, and was the journalists' first point of contact with Blu.

The event itself was named the 'Blu Bar & Lounge', and was a unique environment created within the Naxos Halle in Frankfurt for the purposes of entertaining the press and revealing the Fiesta. Entry to the event was via a bluovalclub branded entrance into a large antechamber in which the entire line of small Ford of Europe vehicles was displayed, and where membership cards were swiped and access to the Blu Bar & Lounge permitted. This precursor to the event provided an environmental embodiment of the club, which emphasised its function as the agent through which this and future events would be delivered.

The Blu Bar & Lounge itself succeeded in the delicate task of establishing its own identity, while integrating that of the All New Ford Fiesta. Common themes of circles in both identities were picked out, while the distinction between the two was maintained with the use of the dominant colour of blue for all Blu-branded items, and white with secondary colours for Fiesta-related items. Prior to the event and the reveal of the vehicle, only the Blu brand was exposed. After the reveal, the Fiesta identity was integrated, with its coloured circles motif projected within the environment, and related items such as giveaways and literature featuring both Blu and Fiesta identities.

The creation of a specific environment provides the opportunity to promote a product and values to a targeted and consenting market – in this case to the media rather than the consumer or dealer. Unlike other purpose-built environments featured in this book (see IBM and Orange Studio) the Blu Bar & Lounge was a one-off phenomenon. It therefore had the advantage of developing an identity that complemented the parent brand but was distinctive in its own right, in order to produce a unique and extraordinary event that surpassed those of its competitors.

'The Blu Bar & Lounge was so different in style to previous events that its contemporary nature has made it a benchmark for future events.' – Paul D. Harrison, Manager, Product Launch and Auto Shows, Communications and Public Affairs at Ford of Europe.

0.1 development – blu bar & lounge ↗

Many variations of Blu were generated before the final name and spelling were agreed upon.

0.2 development – bluovalclub ↗

Bluovalclub, while functioning as the 'holding' brand for future events, was developed after the final version of Blu Bar & Lounge in order to benefit from the crucial design decisions that were reached during the development of the event identity.

0.3 final design – blu bar & lounge ↗

The redrawn font, based on VAG Rounded, was replaced by the Ford brand typeface Helvetica Neue Extended. This brought it in line with other Ford sub-brands. Neat graphical devices were included to give life to each logo. The dual circle motif in Blu Bar & Lounge echoed the design of the central bar itself with its satellite lounges, and also reflected the circles of the separate Fiesta identity.

0.4 final design – bluovalclub ↗

An italicised 'o' in bluovalclub acknowledged the oval of the parent brand Ford's identity. The arcs above and below the logotype are the halves of a bisected oval, positioned to balance the overall shape of the logo.

0.5 development of identity ↗

The event consisted of a central bar plus several themed rooms orbiting the main space. A look and feel was developed for the rooms that reflected the theme of each and also the overall identity.

0.6 final designs – satellite rooms ↗

These icons were honed to echo the shapes present in the Blu Bar & Lounge identity, and to convey the theme of each room without words, in accordance with the pan-European language-neutral nature of the event.

0.7 bluovalclub – website

While ostensibly serving the purpose of registration for the bluovalclub, the site was also to be used to disseminate advance information about the All New Ford Fiesta to member journalists, and to maintain interest in the forthcoming event by keeping it 'top of mind'.

Similar to the arrival at the event, the Blu Bar & Lounge site was accessed via the bluovalclub site. This reinforced the feelings of privilege and exclusivity that the club provided.

0.8 bluovalclub – competition

A competition was devised whereby member journalists from across Europe would test their knowledge of the Ford brand, and compete against fellow writers. Questions were updated weekly and a 'leaderboard' of scores was published on the site, listing the names of the competitors and the publications for which they worked. As expected, the desire to trump competitors saw sustained interest and maintained site hits up until the day of the launch.

0.9 bluovalclub website – games

Downloadable screensavers and Flash-based games were also included on the website. These sustained the presence of the brand, which was discreet but ever-present throughout gameplay, and on monitors when the screensaver was activated.

1.0 menus ↑

Menus were for the launch event only, so they were produced in smaller quantities with more freedom allowed in choice of material, print process and design creativity.

1.1 membership pack ↗

After registration on the website, a pack was sent out to all members. Among other items, it featured a membership card that would allow the journalist access to the Blu Bar & Lounge.

blu
bar & lounge

frankfurt **september 10 01**

bluovalclub

bluovalclub

bluovalclub

bluovalclub

This is
as y

e keep it safe
bar & Lounge

FRANKFURT SEPT 10 0

blu
bar & lounge

bluovalclub

Hanns-Peter v. Thys.-Bornemissza

440W5461

the all new ford**fiesta**

1.2 cds ↑ ↗

End-of-night giveaways such as CDs featured dual branding, with the Fiesta and its new brand identity now revealed.

1.3 items ↑ ↗

The decision as to whether an item should feature bluovalclub or Blu Bar & Lounge was determined by its purpose and on-life.

1.4 matchbooks ↑

Determining factors for on-life included minimum quantity, e.g., matchbooks were produced to minimum orders of 5,000, so plenty would be available for future events.

project 1.2 suma

Spanish supermarket chain Suma required a new brand identity that would reflect their status as an enterprise too small to be seen as national, but too large to be seen as local, covering an area including Catalonia, Valencia and Aragon. Barcelona-based design consultancy Summa were appointed for their extensive experience in retail roll-outs, with a portfolio including Pans & Company – a Catalan fast-food chain for whom they had developed a new identity and store designs – and a series of other food and cosmetics chains. Also, the consultancy's affinity with a wholly Spanish retail culture provided them with an understanding and insight that may have been beyond international agencies.

The brief was to create a new concept for Suma's chain of thirty-five small urban supermarkets, which appealed to young couples with children. These couples all value commodity and proximity, and have little time for grocery shopping. Young urban families are often visually conscious, so the solution needed to be dynamic, young and casual, but functional and accessible.

Inspiration for the new brand language was drawn from the art and styles of early 20th-century Spanish culture. This was to provide an identity that would be familiar and welcoming for customers, and that would project traditional values. The typographic style used for the Suma logo and own-brand packaging evokes the bold dynamic art of the Dada movement. Woodcut illustrations, based upon images found on wooden fruit boxes used by retailers many years ago, convey a fresh and natural image. The illustrations are rendered in a variety of bold, flat colours and applied across high visibility media, including delivery vehicles, in-store aisle signage and staff aprons. The 'holding' colour of black is not normally associated with food retail, but its use heightens the vibrancy and visibility of the coloured illustrations, unifying the various elements of the identity and establishing black as the common corporate colour.

Materials relating to street fresh-food markets were adapted and used extensively in-store, including wood in fruit and vegetable areas to suggest a traditional environment. Also, the use of standard materials allowed the design programme to remain within budget. Store façades eschewed modern illuminated signage and materials in favour of an arch reminiscent of stores in 1900s' Barcelona. The technology used in the flooring, cash registers and trolleys was more advanced than that of competitors, but its understated and discreet application enhanced the customer's shopping experience without detracting from the visual environment. The combined effect provided an industrial and natural look and feel, as opposed to the cold artificiality of many superstores. This distinguished Suma from competing supermarkets and reinforced the chain's desired image of being intimate and local, rather than corporate and national. Summa's solution succeeded in surpassing the conventions of supermarket branding, while drawing extensively on tradition and history.

'The response has been very positive from the first day. Sales have been increasing steadily since the opening of the first store. Our client is delighted and we are working to complete a total of thirty-five stores by 2002.' – Wladimir Marnich, Design Director at Summa.

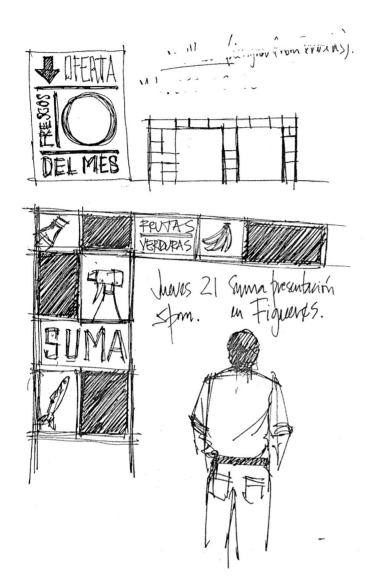

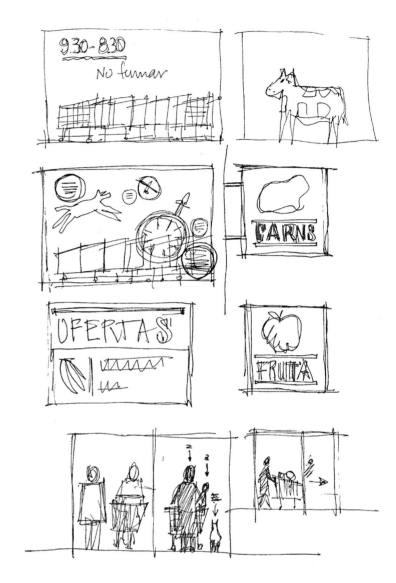

0.1 sketches

The initial stages of environmental and packaging identity for the supermarket chain consists primarily of sketchwork. Even at this stage, it is possible to identify distinct themes that later emerge in the final brand. The confident use of illustration and strong application of typography form a foundation for the later brand development.

Suma *Suma* Suma

suma **suma** **suma**

SUMA SUMA SUMA

0.2 typographic reference ↗

Early research of typographic styles, constructivist typography and 'found' eclectic patterns of type, which feature later in the final packaging.

0.3 word study ↗

Developmental studies into the logotype 'suma' showed how capitalisation and italic letterforms change our perceptions of the identity. The final identity opts for a mix of upper- and lowercase letterforms, creating a 'youthful', energetic and accessible logo.

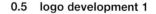

0.4 typography ↗

Inspired by constructivist references, a series of woodcut interpretations of the logo are created. Notice the lowercase 'a' (top left), which features prominently in the final identity.

0.5 logo development 1 ↗

A simple box device is introduced to 'contain' the eclectic feel of the typography. Colour considerations are important in the development of the logo, the vermilion colour of the early logo experiments re-emerges in the final identity.

0.6 logo development 2 ↗

An alternative route for the logo referenced crate packaging with the use of stencil typography.

0.7 final logo ↗

Although not usually associated with food retail, the solid black holding colour emphasises the vibrancy and 'freshness' of the final logo.

PLÀTAN	€			FRUITES
ORIGEN	VARIETAT	CALIBRE	CATEGORIA	

TARONJA	€			FRUITES
ORIGEN	VARIETAT	CALIBRE	CATEGORIA	

MONGETA FINA	€			VERDURES
ORIGEN	VARIETAT	CALIBRE	CATEGORIA	

CARXOFA	€			VERDURES
ORIGEN	VARIETAT	CALIBRE	CATEGORIA	

0.8 labels ↗

A generic packaging label system has been developed for items that carry minimal branding and packaging. Shown above, top to bottom, are labels for bananas, oranges, green beans and artichokes.

Simple woodcut illustrations are combined with clear and informative typography to create labels reminiscent of the silk-screening found on packaging crates.

0.9 façade study ↗

Early research into the entrance style of the façade.

1.0 technology ↗

Mood board on the theme of supermarket technology achieving innovations in customer interactions with product and interfaces.

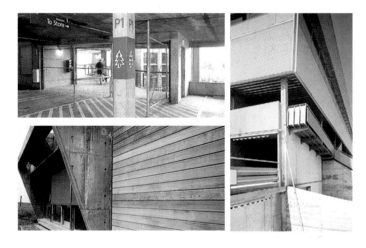

1.1 natural ↗

Mood board prepared on the theme of natural product packaging – simplified and unbranded.

1.2 industrial ↗

Mood board which explores the theme of industrial architecture – complementary mixtures of natural and manmade materials.

1.3 façades ↗

Research carried out on local façades reveals the eclectic 'hand-applied' nature of signage and shop decoration. Direct reference is made to comparable retailers and liquor stores while influence can also come from garages and other unlikely sources.

1.4 mobile ↗

Research into store movement and moveable installations.

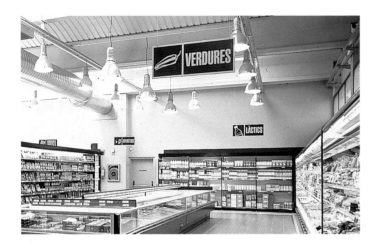

1.5 interiors ↑ ↓

Within the store environment, high-level signage is used to indicate distinct areas. The application of the black holding colour helps to identify the signs as part of the store identity.

1.6 delicatessen ↑

The assurance of natural and fresh produce is simply and effectively imparted through delicatessen-style packaging.

1.7 colour study ↑

To ensure individuality and prominence, a colour wheel is used to locate the identities of current competitors. The Suma identity is perhaps unique among these competitors because of its refusal to adopt a strict 'corporate' approach to colour usage.

1.8 colour selections ↓ ↑ ↙

The final colour selections were made to be applied across a wide range of products. From transport to personnel apparel, the consistent application of the colour selections onto the black holding background creates a strong and memorable identity.

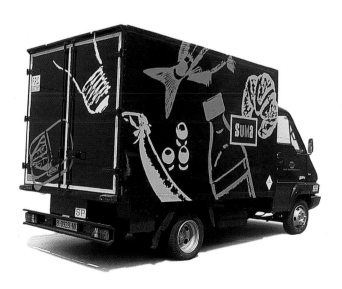

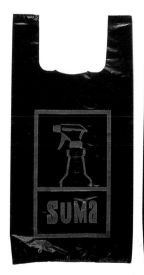

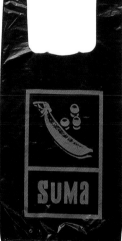

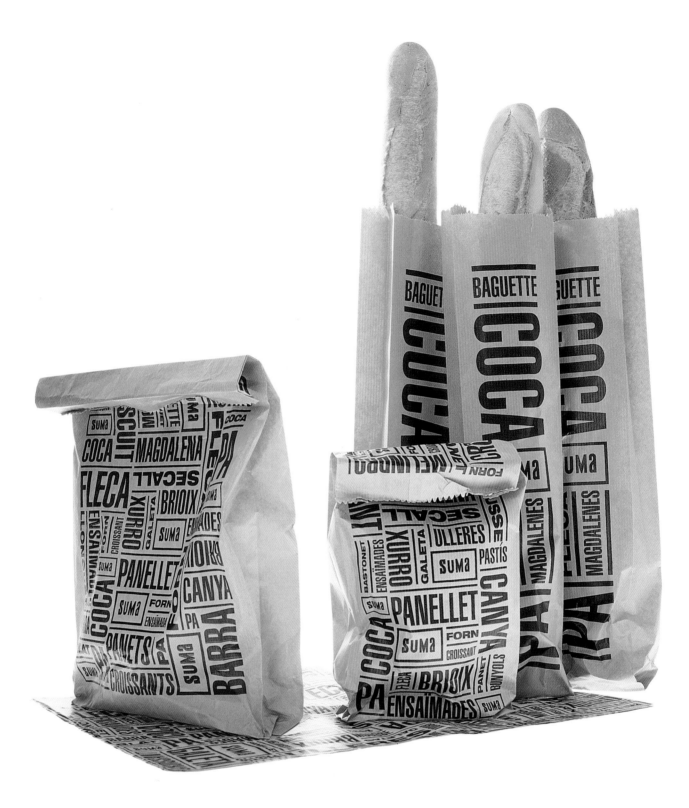

1.9 packaging

Reminiscent of retail patterns from many years ago, the deli-style packaging instills the feel of 'hand-picked' and ultimately 'fresh' produce. The sophistication of the packaging however is a far cry from the bland ubiquitous approach of many other comparable retailers.

Importantly, the packaging not only serves a pragmatic purpose to protect, but also imparts a euphoric enjoyment and celebration of the produce.

project 1.3 orange studio

In order for a brand to maintain and extend its presence in today's information-saturated climate, it must expand into areas in which we may not expect to experience a brand, but which have natural associations with the brand. For example, Virgin, taking advantage of the music arm of the corporation, organise and run high-profile branded outdoor music festivals throughout the UK; Rizla, manufacturers of tobacco rolling papers, have capitalised on the presence of their product in youth culture to move into environmental branding at music festivals, and to produce a range of branded clothing and accessories; Nike, forerunners in the drive to transcend the parameters of branding, utilise their associations with health and fitness to sponsor sports events in areas such as basketball, soccer, golf, running, and community sports days.

Orange, one of the four mobile phone service providers in the UK, has also pushed its brand into alternative channels of marketing. In developing new initiatives to transform customer perceptions of the company as solely a mobile phone service provider, Orange focused upon the manifest purpose of the company – communication. It was decided that the various means of communication available to people today were to be brought together within what the design agency Atelier Works calls 'a multifunctional space where all kinds of people can communicate at different levels'. The Orange Studio was launched in October 1999, in Birmingham city centre, UK, to serve the functions of an internet café, a high-tech conference centre, a graphics bureau, an IT training centre and a restaurant and bar. It was to be an environment conducive to the meeting and interaction of individuals, groups and businesses, in which they could communicate both face to face, and through the various technological facilities provided.

UK design agency Atelier Works were appointed to develop the Orange Studio as a sub-brand that could work alongside the parent Orange brand, but that would retain a distinct identity. Regular brainstormings were undertaken with the client, and all aspects of the Studio were addressed – from the naming of spaces to whether the cappuccino should be hand-made or from an Italian machine – in order to maintain the quality of everything associated with the brand.

A graphic language was developed that was based upon simple icons, designed to instantly communicate specific themes and ideas related to the Studio. The manifestation of the icons as simple line-art drawings allowed them to be used across a variety of media – from shop fascias and print-based mailers and brochures, to screen-based motifs – without a loss of legibility. Also, costs were kept low due to inexpensive single-colour printing of the monochromatic icons, and the absence of image usage fees or commissioned photography.

The Orange Studio successfully fulfils Orange's aims to be seen as a 'total communications company'. The establishment of an exclusive, branded environment provides Orange with a showcase centre through which it is able to espouse its brand values of user-friendliness, simplicity and approachability, while demonstrating its ability to enhance the customer's communications experience. The open-door convenience of the Studio means that passers-by are able to drop in or pre-order refreshments and meals, to surf the internet and to send and receive email while experiencing the Orange brand in an unobtrusive manner.

0.1 visual language ←

This press advertisement shows the simple outline shapes of the Orange Studio icons, which echo the clarity and economy of form of the Orange logo and namemark, while providing the Studio itself with a light-hearted personality. This graphic language has the versatility to work across all media, both outside the Studio in promotional campaigns, and within the actual environment.

0.2 promotional literature ↗

Prior to the opening of the Studio, a direct mail brochure utilised the icons to establish the brand identity in the minds of potential customers, under the campaign headline of, 'Choose the way you want to communicate'.

choose the way you want to communicate

0.3 in-house branding

The versatility of the visual language is again demonstrated in its ability to work in both large and small scales. Web pages to promote the site are able to carry the icons due to their simplicity and small download size.

In-house stationery is colourful and lively, utilising the icons, a simple colour palette and two-word soundbites to evoke the ambience of the environment.

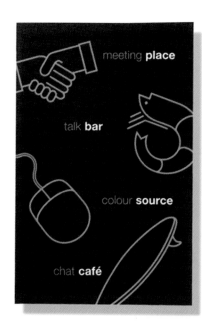

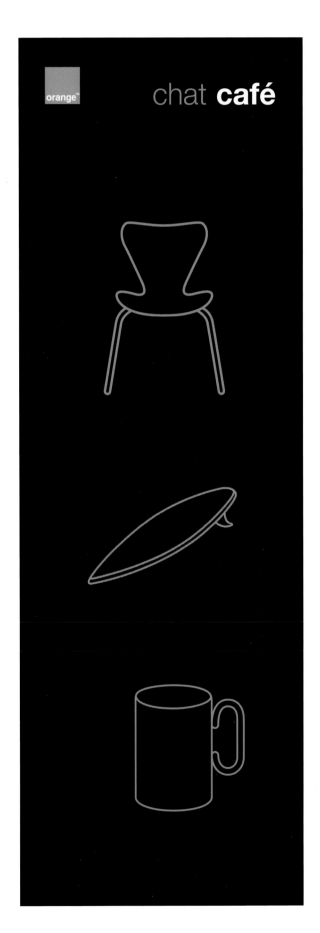

0.4 banners ↘ ↗

Large format banners carry the familiar Orange logo within the visual elements of the Orange Studio brand. This demonstrates the easy adaptability of the graphic language, and its affinity with the Orange brand.

'Orange move very quickly and so do the ideas. Since the building was being refurbished whilst the graphic design work was still in progress, the solution had to be simple and adaptable.' – Atelier Works

0.5 refreshments packaging ↙ ↖

The Chat Café, an area within the Orange Studio, features single-colour icons upon white packaging. Fun words related to the product are used in conjunction with the icons to establish the tone of the area as friendly and inviting.

0.6 business literature ↘

The overall nature of the Orange Studio means that the brand language must speak not only to casual customers, but also to business clients. Therefore a more sober tone of voice is necessary with business-related material. The colour scheme is more subdued and the icons less playful, but the overall tone of accessibility that the graphics provide is maintained.

tariffs

menu

terms and conditions

location

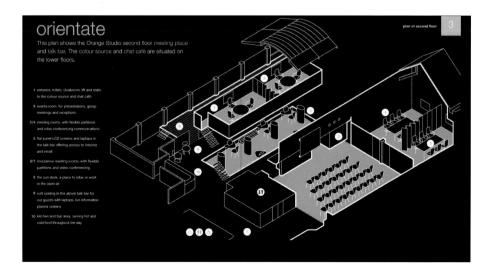

project 1.4 coca-cola

Coca-Cola is the most widely recognised brand in the world, topping Interbrand's global brand league, and leaving other international giants, such as IBM, Ford and McDonald's, in its wake. According to the Superbrands organisation, it is the most recognised trademark in the world with '94 per cent global recognition', and is worth an estimated '72.5 billion dollars'. Coca-Cola's influence reaches well beyond the boundaries of marketing and consumerism into the very heart of world culture. In the West, Coca-Cola is credited with lending its brand colours of red and white to the image of Santa Claus, while Superbrands credits Coca-Cola as 'the second most widely understood word in the world after OK'.

When a brand attains this level of saturation, and its worldwide exposure is guaranteed due to the ubiquity of the product, we may be forgiven for questioning the need for a corporation to continue pumping millions of dollars a year into promotional campaigns. But the brand war is ongoing. With high-quality own-label supermarket colas steadily acquiring greater percentages of market share, and the ever-present competition of Pepsi-Cola, 'the world's second-largest beverage company' according to Superbrands, Coca-Cola must strive to devise bigger and better means of promoting its brand.

In 2000, Coca-Cola produced the world's largest photo-mosaic, consisting of an image of the trademark bottle and logo applied to the façade of a skyscraper. The location of this 'super-ad' was the Latino Building in Monterrey, Mexico, and its 5,400 photographs spanned a total surface area of 1,350 square metres. The concept, developed by the in-house advertising agency of the Grupo PROCOR bottling company (who control the North Mexican brand rights for Coca-Cola), involved photographing the people of Monterrey and creating the mosaic from their images. The strapline of the campaign, 'Tu Formas Coca-Cola' ('You are part of Coca-Cola'), was literally realised. In order to view their images within the montage, the contributors could pay one peso to use one of three telescopes located in the adjacent Macroplaza Square. The profits from these viewings were donated to the Mexican charity DIF Nuevo León.

When discussions on sustaining brand exposure encompass the projection of logos onto the surface of the moon, the scale of the Monterrey photo-mosaic pales in comparison. But whereas brands may continue to think big, the inevitable public backlash against the corporate appropriation of vast swathes of skyline indicates that size is not everything. When, in 1997, Canadian advertising company Murad branded almost every building in the busiest part of Toronto's cultural centre, Queen's Street West, with a campaign for Levi's® Silver Tab jeans, the backlash from residents and visitors was vociferous and ferocious (see Naomi Klein, *No Logo*).

Therefore the quality of inclusivity, of relating an ambitious branding exercise to the people whom it directly affects – in Coca-Cola's case the citizens of Monterrey – becomes crucial to the success of the strategy. The awesome experience of seeing a seventy-five-metre high image composed of people's faces is only heightened by the realisation that one can become a part of it. And this desire to be included in the event inevitably involves the sanctioning of the exercise. Coca-Cola's involvement in the creation of a social event with the implicit consent of the people of Monterrey provided legitimacy to the campaign, and enabled it to achieve its goals of making a bold statement of the product's status and intent, while expounding the brand value of 'You are part of Coca-Cola'.

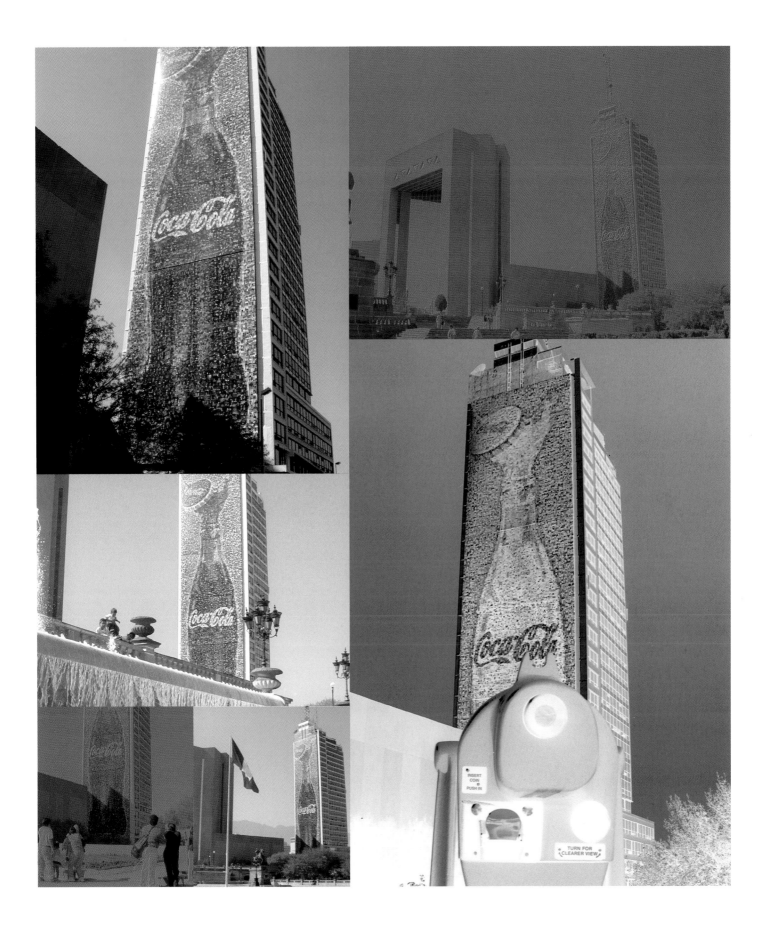

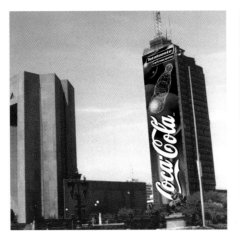 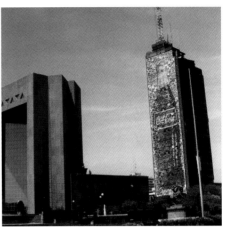

0.1 invitation ↙

Invitations to a viewing were sent out to a section of the population of Monterrey. Each invitation contained a one-peso coin, which, when inserted into a viewing station, would buy one minute's viewing time of the vast image.

0.2 the process ↑ ↗

'The process of developing a photo-mosaic is exactly the same as that of any printed image; that is, it contains a mixture of colours or pixels that form the whole image. Each photograph is saved as a digital file which is later treated with special software that fixes every picture in order to build up a specific image. The fixing of every photograph is carried out according to its chromatic value, since none of the pictures are altered from their original colour.

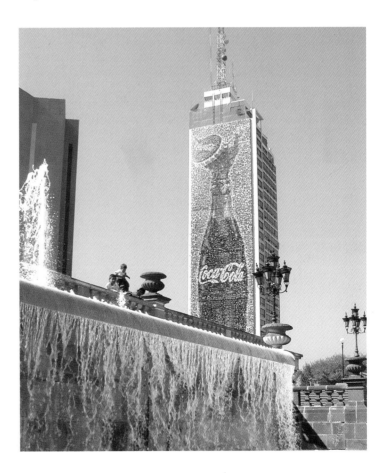

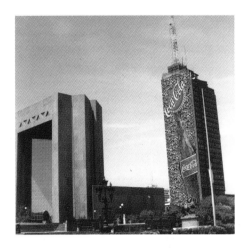

'In order to gather the 5,400 pictures, it was necessary to hire a brigade of seven photographers who were able to take all the images within one week. In order to avoid the need for digital scanning of images, which would be time-consuming and diminish picture quality, it was decided to use professional digital cameras. Once all the images were taken, the data was processed using RUNAWAY Technology's special software and the files were given to the canvas manufacturers.

'The canvas supplier was found in Mexico City, since high-fidelity printing was required in order to be able to distinguish the photographs. Each canvas measured 82 x 59 feet, making up the final size of 75 x 18 metres. As a final process, a group of workers were hired who were in charge of maintenance, pre-set-up, and finally the setting up of the photo-mosaic.' – Grupo PROCOR.

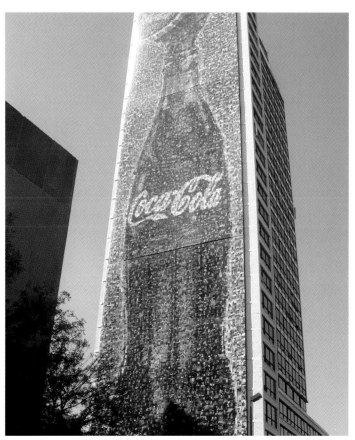

project 1.5 do create

'The KesselsKramer agency in Amsterdam wants to turn those lame-duck couch-potatoes into active consumers' – *Form* magazine, June 2000.

Do, by Dutch advertising agency KesselsKramer, is the first brand to exist without a specific product. The concept of do arose in 1998, when KesselsKramer's idea of a 'do-Center' to present branding and advertising for the Dutch Metropolis Museum, with an emphasis on activity, was rejected. The agency retained the concept and developed it into 'an ever-changing brand depending on what you do'. Do took many forms, from the numerous book projects of do publish, to a 24-hour online forum about the future of television. But the agency felt that the concept had much more potential, and so they joined forces with radical product designers Droog Design to form do create – a brand whereby the consumer must engage with a product to 'activate' the brand.

Do create consists of a ready-made logo, a concept and, vitally, the willing participation of anyone who wishes to embrace the ethos of do. Do create encourages anybody from the lay consumer to the high artist to propose an idea. The design agency helps with production and communications, but the idea for the product itself can come from any source. This 'blank canvas' approach gives rise to a proliferation of ideas and products that range from the comedic and ironic, to the inspired and profound – effectively reflecting the diversity of human response to product and consumer culture, and providing a catalyst for a richness of thought and creativity that otherwise may not have had an opportunity to be expressed.

By its very nature, the unconventional and remarkable concept of do create defies judgement – one cannot decide if it genuinely encourages consumer participation, or if it mocks the brand culture of modern society. Is do create selling a radical approach to the product by marketing a lamp that consists only of a shade and base, and encouraging the consumer to decide what goes in-between? Or is this a case of the emperor's new clothes? The do create products are reminiscent of the paradoxical 'invisible action figure', an actual manufactured and marketed product consisting of an empty vac-moulded pack that features instructions encouraging the purchaser to use his or her imagination. The instruction is for an undoubtedly beneficial activity, but the marketing of this concept short-circuits the autonomy of the consumer – he or she must first purchase in order to function. Similarly, do create provides the raw materials and the instruction, and the consumer participates creatively. But he or she does so in response rather than independently. The crucial involvement of the consumer in the realisation of the concept affects the subsumption into the brand machine. The consumer's subjugation at the foot of the brand is active and complicit, rather than passive and unconscious. Do create raises awareness of the influence of brands, and the consumer's relationship with them. The challenge to do is almost a call to arms, an entreaty to become aware of brands, to recognise them and challenge their role in our lives.

In a report for UK television's Channel 4, Naomi Klein points out how the brand has evolved into 'a free-standing idea pasted onto innumerable surfaces', and cites do create as a 'prototype for the brand of the future'. This is only part of the story. Do create is a paradox. In its incarnation as the world's first post-modern brand, it is both appeaser and agitator, offering a blueprint for the future of the brand, while lampooning the aspiration of modern brands to become a way of life, not simply a mere commodity.

Examples shown within this project include **do add** (chair with uneven legs) by Jurgen Bey, **do reincarnate**, **do scratch**, **do eat** and **do link** by Martí Guixé, **do hit** by Marijn van der Poll, **do swing** by Thomas Bernstrand, **do connect** by Dinie Besems and Thomas Widdershoven and **do break** by Frank Tjepkema and Peter van der Jagt, with photography by Bianca Pilet.

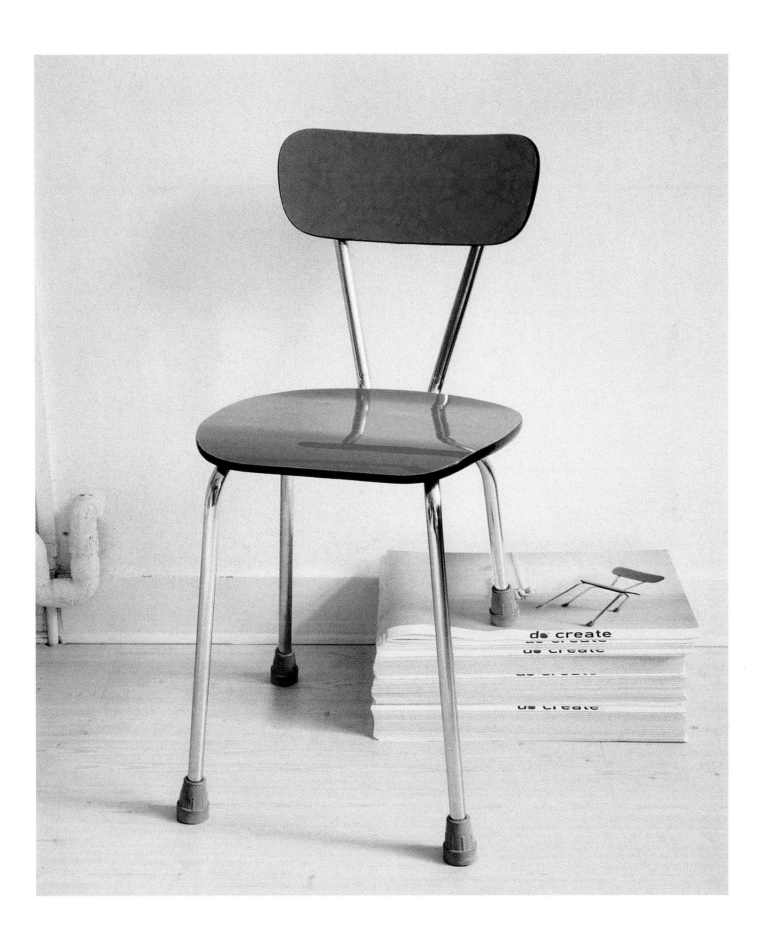

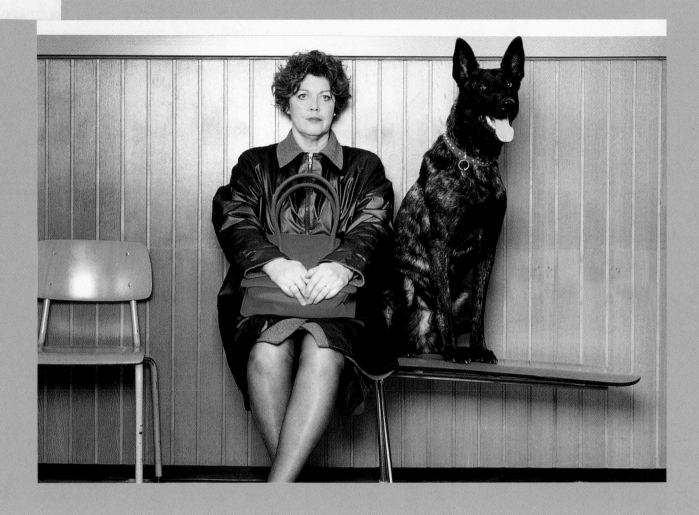

0.1 do logo ↖

Do consists of a ready-made logo and the radical concept of a brand 'to which consumers can assign products themselves', in the words of the do create press release.

0.2 visual language ↗

'This is not really about the products, but about photos and concepts, all of them feedback from the brand and product world conveyed to us by the media.' – *Form* magazine, July 2000.

The visual language of the promotional do create brochure is direct and deceptively simple, with an understated line in social satire and deadpan execution. The photography that accompanies the description of every do create product concisely illustrates the elements that define it – concept, participation and execution.

For instance, do eat portrays a nuclear family of mother, father and their children, a boy and a girl, in the setting of an average family dining room. There is a Mickey Mouse tablecloth on the table; the parents wear nondescript casual-wear; the little girl is playing a game with the cutlery. Within this mundane scene, the father is cutting out plates from a large plastic sheet in preparation for their meal. As in most of the photography in the brochure, active participation with do create products is portrayed as an inherent and fundamental part of everyday activity. Their place is not in the high art conceptualism from which they originated, but in the functional utilitarianism of the everyday.

The diagram and description of use which accompany each product are idiosyncratically deadpan, the three-stage illustration demonstrating with condescending simplicity how to cut the plates from the sheet. The sign-off line helpfully suggests that 'you don't necessarily have to do the washing-up, unless you want to "do recycle"'.

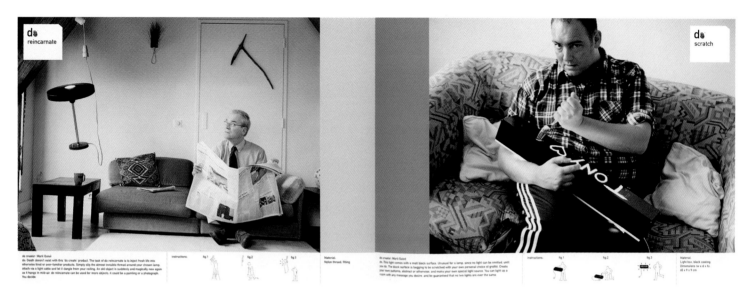

0.3 do reincarnate ↗

Do create products provide a starting point from which the consumer can develop a bespoke product. With the line, 'Death doesn't exist with this do create product', do reincarnate artfully hypes the most basic of commodities, nylon thread, as a vehicle for revitalising one's most tired possessions. 'Simply slip the almost invisible thread around your chosen lamp', expounds the accompanying copy, 'dangle from your ceiling, and an old object is suddenly new again as it hangs in mid-air.'

0.4 do scratch ↗

Do scratch encourages the consumer to scrape away the black surface of a lightbox to create 'your own special light source'. The accompanying photograph of Joe Public intensely carving the names of himself and his partner into the lightbox is a pointed vignette of urban banality.

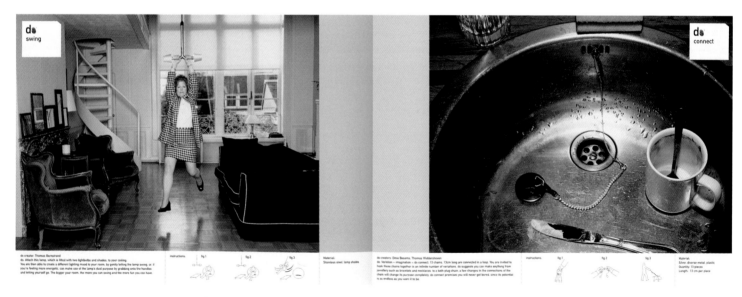

0.5 do swing ↗

Do swing and do connect are the ultimate in multifunctional utilitarianism. Do swing consists of two lamps attached to a t-shaped handle, which must be fitted to the ceiling. It can then serve the dual purpose of a lighting utility or an exercise bar.

0.6 do connect ↗

Do connect consists of a chain that can be looped and reattached in many variations in order to be used as a bracelet, a necklace or a sink plug chain. Do connect promises that 'you will never get bored, since its potential is as endless as you want it to be'.

These products provide wry commentary on the preponderance of the brand over the product in the eyes of the consumer, and subsequently the possibility of remarketing any product if the brand is seen as desirable.

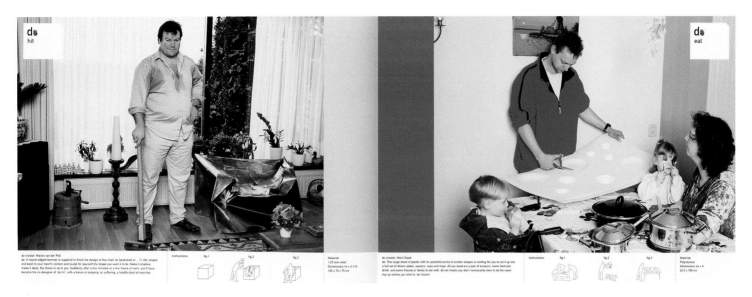

0.7 do hit ↗

Do hit made its debut at the Milan Furniture Fair in April 2000, on the stand do + droog design = do create. It consists of a block of 1.25mm steel with dimensions of 100 (w) x 70 (d) x 75 (h)cm.

'To sit in the chair you have to "find it" in a cube of sheet metal, using a sledgehammer for assistance.'
– Nick Compton, *i-D* magazine, February 2000.

0.8 do eat ↗

The subtext that consistently runs throughout the do create brochure insinuates social dysfunction within capitalist society. Do create infer that the concept of an overarching, non-specific brand is not suggested as a solution to social malaise, but a symptom of it.

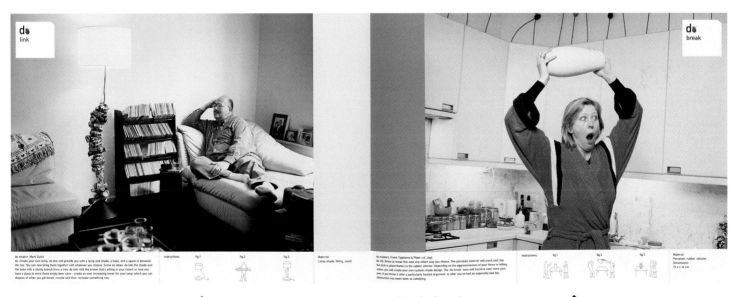

0.9 do link ↗

'Environmental and social concern are part of this philosophy, as are having fun and rehumanising the objects in our lives that "become part of us". The touchy-feely, utopian ideals behind do create are apparent in do link, a free-standing half-lamp that you are encouraged to complete using recycled materials.' – Nick Dent, *Black + White* magazine, August 2000.

1.0 do break ↗

Do break consists of a porcelain vase with a rubber interior, the creators of which encourage one to 'hit, throw or break this vase in any which way you choose'. Again, the related image is a snapshot of private urban angst, a housewife on the brink of paroxysm frozen at the point of destroying the do break vase. The three-figure illustration below the image conveys an act of reconciliation beside the reconstituted ornament.

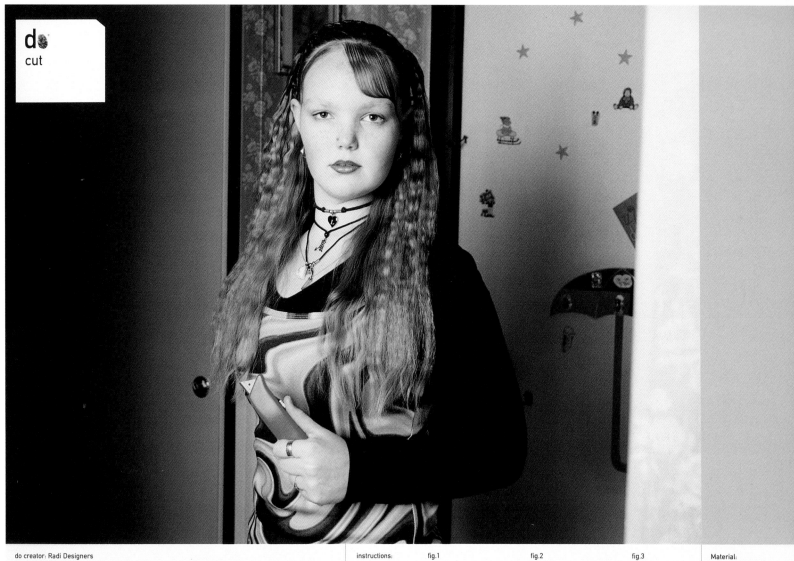

do creator: Radi Designers

do: At first glance, the shapely, long totem pole is simply an abstract ornament to place on a shelf or next to a fireplace and ignore. However, on closer inspection, you can see that the grooves of the design are begging to be sawn. do cut can be transformed, with a few simple slices, into a stool, a vase that rocks slightly to and fro, an umbrella-holder, a lampshade and other ideas that you can think of just by giving it closer inspection. (See over for 'do cut' variations.)

instructions: fig.1 fig.2 fig.3

Material:
Roto-moulded polystyrene
Dimensions:
33 ø x 125 cm

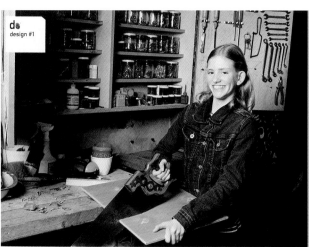

do creator: Dick van Hoff

do: You have in front of you a large piece of wood (122 x 244 cm) with the do logo etched repeatedly into it. And with the do-branded wood comes a series of design suggestions from the do creator of the piece. This is the ultimate do it yourself product which, no matter what you decide to make with it, will always come signed by the mark of do and the proof that you have, indeed, done.

instructions: fig.1 fig.2 fig.3

Material:
Multiplex wood in 8 mm and 15 mm
Dimensions (w x l):
122 x 244 cm

do creator: Dick van Hoff

do: Do it yourself comes in an altogether different form with do design #2, this time a long roll of material with the do logo melted into it at frequent intervals. The instructions accompanying this do design, give a variety of lamp-shade styles that you can create and call your own.

instructions: fig.1 fig.2 fig.3

Material:
Polypropylene
Dimensions (w x l):
89 x 100 cm

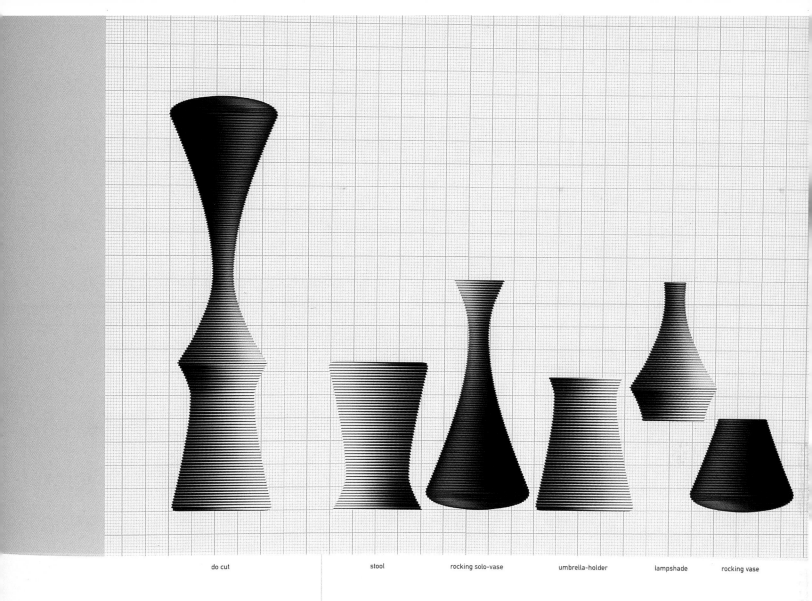

do cut stool rocking solo-vase umbrella-holder lampshade rocking vase

1.1 do create products – do design #1 & 2

Do design #1 consists of a large piece of wood featuring the do logo etched several times into the surface. In response to the consumer's desire to own a piece of branded merchandise, any application of do design #1 will feature the do logo as 'proof that you have, indeed, done'.

Do design #2 translates the concept of do design #1 to fabric, featuring the do logo melted into the fabric at frequent intervals, and encouraging the consumer to create lampshades from the instructions supplied.

1.2 do create products – do cut

Do cut consists of a totem-like column of roto-moulded polystyrene, height 125cm and diameter 33cm. Inlaid with a series of grooves, it can be cut into a variety of different forms to be used as a stool, a vase, a lampshade etc. The genuine practicality and achievability of the do products is underpinned by the brand's satirical observation of the commercial appropriation of humble utility, and the marketing of pragmatism.

1.3 do frame ← ↑

Do frame encapsulates the essence of do create, demonstrating the ambiguous approach to brand and product that is its trademark. A thick roll of tape printed with an ornate black and gold pattern is marketed as a DIY frame. Included are simple instructions rendered with the typical do execution of enthusiasm and deadpan sincerity, informing the user that, 'instantly, do frame can turn something mundane into a potentially spectacular work of art'.

Participants in the framing exercise are invited to submit their applications of the frame for inclusion in an on-line gallery, which features an eclectic selection of ironic and innovative uses of the product. This concept can be compared to material produced by UK advertising agency mother for britart.com, whereby conventions of the contemporary art scene are simultaneously lampooned and emulated.

1.4 do future ↑

Do future is a perfect-bound paperback book featuring an eclectic selection of propositions, predictions and anecdotes from more than thirty authors from around the world. It is a book about 'the future', which is kept up-to-date by continually scribbling over old editions 'until interest dries up or we have run out of space in which to scribble'.

The book has no permanent cover. Upon each rerelease it is simply shrink-wrapped and screen-printed with a title. In the true spirit of a throw-away consumer society, the cover must be discarded to access the product.

The book's content continues the tongue-in-cheek tone of the do series. One contribution features an extract from British Prime Minister Tony Blair's book *The Young Country*, the words of which are edited to prepare it for the future. Blair's words are reconfigured to read, 'I want to... party... That is... the future... people love... to party.'

contributors >

0.1 **Design Group:** Design Bridge
Project: connexxion

Brand Strategy Max du Bois, Stefan Bufler
Creative Direction Stefan Bufler
Designers Mike Callan, Ramses Dingenouts,
Adrian Potter, Victoria Evans

Design Bridge, 18 Clerkenwell Close, London EC1R 0QN, UK

T +44 (0)20 7814 9922 **F** +44 (0)20 7814 9024
E gilles.guilbert@designbridge.co.uk **W** www.designbridge.co.uk

0.2 **Design Group:** Imagination
Project: Mazda

Designer Andrew Monk

Imagination, 25 Store Street, London WC1E 7B, UK

T +44 (0)20 7323 3300 **F** +44 (0)20 7323 5801
E claire.chapman@imagination.com **W** www.imagination.com

0.3 **Design Group:** Browns
Project: Interiors bis

Creative Director Jonathan Ellery **Designer** Jamie Roberts
Project Manager Philip Ward

Browns, 29 Queen Elizabeth Street, London SE1 2LP, UK

T +44 (0)20 7407 9074 **F** +44 (0)20 7407 9075
E info@brownsdesign.com **W** www.brownsdesign.com

0.4 **Design Group:** Atelier Works
Project: Royal Institute of British Architects

Designers Quentin Newark, Glenn Howard
Lion Crest Draw Roger Taylor
RIBA Logo Draw Pentagram

Atelier Works, Old Piano Factory, 5 Charlton Kings Road,
London NW5 2SB, UK

T +44 (0)20 7284 2215 **F** +44 (0)20 7284 2242
E atelier@atelierworks.co.uk **W** www.atelierworks.co.uk

0.5 **Design Group:** open: a design studio
Project: art:21

Open, 180 Varick Street, 8th Floor, New York, NY 10014, USA

T +1 212 645 5633 **F** +1 212 645 8164
E info@notclosed.com **W** www.notclosed.com

0.6 **Design Group:** Wolff Olins
Project: Powwow

Creative Director Doug Hamilton **Consultant** Nigel Markwick
Senior Designer John Besford **3D Designer** David Rose
Product Designer Lionel Chew, Tim Pope
Account Director Nikki Morris **Account Manager** Becky White

Wolff Olins, 10 Regents Wharf, All Saints Street, London N1 9RL, UK

T +44 (0)20 7713 7733 **F** +44 (0)20 7713 0217
E info@wolff-olins.com **W** www.wolff-olins.com

0.7 **Design Group:** the Kitchen
Project: Levi's®

the Kitchen, 52–53 Margaret Street, London W1W 8SQ, UK

T +44 (0)20 7291 0880 **F** +44 (0)20 7291 0881
E access@thekitchen.co.uk **W** www.thekitchen.co.uk

0.8 **Design Group:** Imaginary Forces
Project: Centers for IBM e-business Innovation

Imaginary Forces Credits
Creative Director Mikon van Gastel **Art Director** Matt Checkowski
Designers Matt Checkowski, Mikon van Gastel
Animators Peter Cho, Chun-Chien Lien
Executive Producers Peter Frankfurt, Chip Houghton
Writer Jed Alger

Design Office Credits
Principal Architects George Yu, Jason King
Project Designers Sandra Levesque, Davis Marques, Kai Riedesser
Music and Sound Design Walter Werzowa / Musikvergnuegen

IFLA, 6526 Sunset Boulevard, Hollywood, CA 90028, USA

T +1 323 957 6868 **F** +1 323 957 6887

IFNY, 530 W 25th Street, 5th Floor, New York, NY 10001, USA

T +1 646 486 6868 **F** +1 646 486 4700
E information@imaginaryforces.com **W** www.imaginaryforces.com

0.9 **Design Group:** Browns
 Project: National Interpreting Service

Creative Director Jonathan Ellery **Designer** Scott Miller
Project Manager Carrie Jewitt

Browns, 29 Queen Elizabeth Street, London SE1 2LP, UK

T +44 (0)20 7407 9074 **F** +44 (0)20 7407 9075
E info@brownsdesign.com **W** www.brownsdesign.com

1.0 **Design Group:** NB: Studio
 Project: Knoll

Designers Ben Stott, Nick Finney, Alan Dye, Nick Vincent

NB: Studio, 60–62 Great Titchfield Street, London W1P 7AE, UK

T +44 (0)20 7580 9195 **F** +44 (0)20 7580 9196
E mail@nbstudio.co.uk **W** www.nbstudio.co.uk

1.1 **Design Group:** PCI LiveDesign
 Project: Ford of Europe

Creative Director John Whittington
2D Designer Matt Lumby
3D Designer Martin Grant
Senior Producer Susie Evans
Director and Executive Producer Fran O'Linn

PCI, 3/18 Harbour Yard, Chelsea Harbour, London SW10 0XD, UK

T +44 (0)20 7544 7500 **F** +44 (0)20 7352 7906
E flick@pciuk.com **W** www.pciuk.com

1.2 **Design Group:** Summa
 Project: Suma

Art Directors Josep Maria Mir, Wladimir Marnich
Designer Anna Sodupe **Project Manager** Josep Maria Bas
Industrial Design Jorge Pensi **Interior Design** Eduardo Campoamor

Summa, Roger De Llúria 124, Planta 8, 08037 Barcelona, Spain

T +34 93 208 1090 **F** +34 93 459 1816
E info@summa.es **W** www.summa.es

1.3 **Design Group:** Atelier Works
 Project: Orange Studio

Designer John Powner

Atelier Works, Old Piano Factory, 5 Charlton Kings Road,
London NW5 2SB, UK

T +44 (0)20 7284 2215 **F** +44 (0)20 7284 2242
E atelier@atelierworks.co.uk **W** www.atelierworks.co.uk

1.4 **Design Group:** Grupo PROCOR (Embotelladoras ARCA)
 Project: Coca-Cola Photo-mosaic

Concept and Creative Director Emilio Cruz Rendon
Project Manager Rolando Cervantes
Art Direction Alejandra Gonzalez & Emilio Cruz
Photo-mosaic Development Rob Silvers (RUNAWAY Technology)

Av. San Jeronimó 813 Pte. Monterrey, N.L. C.P. 64640, Mexico

T +52 81 8151 1400 **F** +52 81 8151 1473
E emiliocr@e-arca.com.mx **W** www.guiaen.com

1.5 **Design Group:** KesselsKramer
 Project: do create

do create, P.O. Box 3240, 1001 AA Amsterdam, the Netherlands

T +31 (0)20 530 1070 **F** +31 (0)20 530 1061
E domail@dosurf.com **W** www.dosurf.com